# JUNETEENTH
# RODEO

NUMBER 25

THE M. K. BROWN RANGE LIFE SERIES

# JUNETEENTH
# RODEO

PHOTOS AND ESSAY BY
## SARAH BIRD

AFTERWORD BY
## DEMETRIUS W. PEARSON

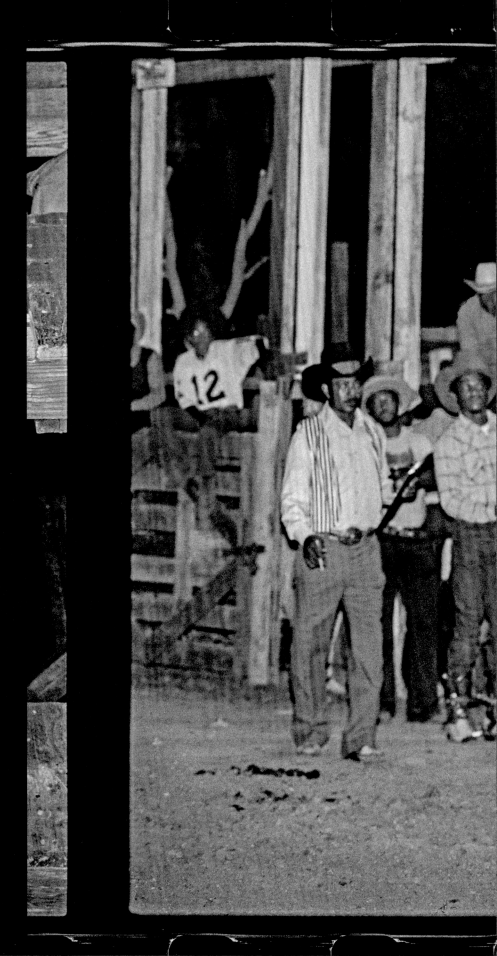

*The publication of this book was made possible by the support of Ellen Randall and is dedicated to her great friend Wilson Scaling.*

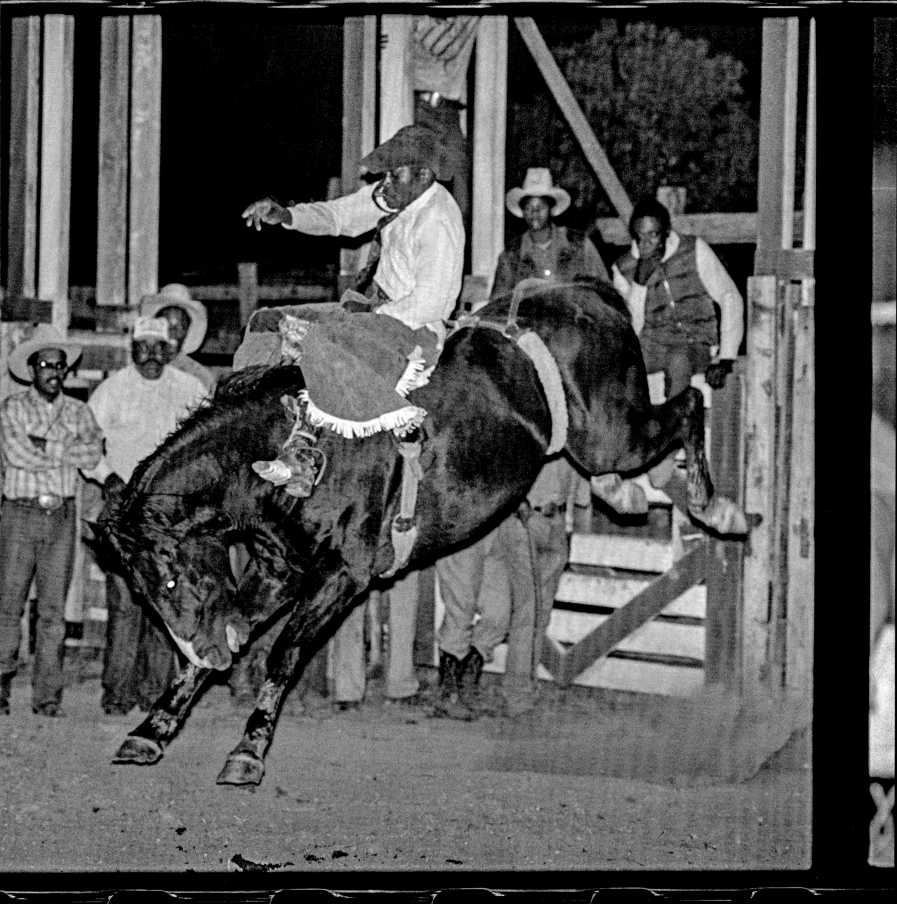

Requests for permission to reproduce material
from this work should be sent to:
Permissions
University of Texas Press
P.O. Box 7819
Austin, TX 78713-7819
utpress.utexas.edu

♾ The paper used in this book meets the minimum requirements
of ANSI/NISO Z39.48-1992 (R1997) (Permanence of Paper).

LIBRARY OF CONGRESS CATALOGING-IN-PUBLICATION DATA

Names: Bird, Sarah, author, photographer. |
Pearson, Demetrius W., writer of afterword.
Title: Juneteenth rodeo / photos and essay by Sarah Bird ;
afterword by Demetrius W. Pearson.
Other titles: M.K. Brown range life series ; no. 25.
Description: First edition. | Austin : University of Texas Press, 2024. |
Series: M.K. Brown range life series ; number 25
Identifiers: LCCN 2023049618
ISBN 978-1-4773-2954-2 (hardback)
ISBN 978-1-4773-2955-9 (pdf)
Subjects: LCSH: Rodeos—Texas—History—20th century—Pictorial works. |
African American rodeo performers—Texas—History—20th century—
Pictorial works. | Juneteenth—Texas—History—20th century—Pictorial works. |
African American cowboys—Texas—History—20th century—Pictorial works. |
Minorities in rodeos—Texas—History—20th century—Pictorial works. |
LCGFT: Documentary photographs.
Classification: LCC GV1834.55.T49 B57 2024 |
DDC 791.8/40976409047—dc23/eng/20231107
LC record available at https://lccn.loc.gov/2023049618
doi:10.7560/329542

Taken at a pivotal moment when the desegregation of rodeos was still honored more in the breach than in the observance and when rodeo competitors with ranch backgrounds were more the rule than the exception, these photos are dedicated to the ropers and riders, the fans, and the many eventual friends who welcomed me into the extraordinary world that was small-town Black rodeo in the late 1970s.

I feel doubly blessed that I have lived long enough to return these images to the communities that created this world, and to see a country where Black cowboys and cowgirls are not only recognized, but celebrated, as the heroes they always were.

# CONTENTS

# PROLOGUE

By the time this book is released, I will be seventy-four. So dramatically much closer to the end than to the beginning. This publication is the fulfillment of what I've thought of as a sacred duty that had to be accomplished before I reached that end: to return these photos and stories to the communities they sprang from.

Though rooted in the enduring tragedy of enslavement, the Juneteenth rodeos I experienced in the late 1970s were triumphant occasions that celebrated fellowship, excellence, and victories both in and out of the arena. While never denying the dark history and profound deprivation that underlay these events, it is that spirit of celebration that I most sought to capture and convey. Through this narrative I hope to explain both why I was drawn to those now all-but-vanished small-town rodeos and what I discovered there.

The journey started a long time ago.

# CENTER
## OF THE
# FRAME

# "I didn't know there were Black cowboys."

I was in a darkroom, and the speaker—let's call him Karl, though that wasn't his name and I don't know any actual Karls—was hovering over my shoulder. He had just caught sight of the faint tracings of a ghostly image of a bronc rider emerging from the print I was swishing through a bath of photo developing solution.

Karl delivered his observation without a hint of malice, just a touch of bemusement, as if he were remarking, "I didn't know there were Italian leprechauns." But that offhand comment told me that I had what every writer, every photographer, searches for: the tale that has not been told, the image that has not been seen by a wider world.

Karl could perhaps be forgiven for not registering the bronc rider as a cowboy. This was 1978, back in the day when the general public believed that the job description for "cowboy" began with "Must wear big hat and boots" and ended with "Only whites need apply."

It was exhilarating to have the photographic proof that this impression was deeply mistaken. Unfortunately for me, an impoverished recent graduate of UT's journalism department, that proof was trapped on negatives and in tiny canisters of undeveloped rolls of film that I had shot at Black rodeos.

Before everyone walked around with the equivalent of an instant darkroom and photo studio that also made phone calls in their back pockets, photography was an expensive proposition. It involved film, paper, chemicals, trays, drying racks, enlargers, and loads of gear I was way too broke to afford. But those trapped images haunted me, begging to be released. Luckily, my buddy Karl was a darkroom monitor who allowed me to slip in when he was on duty and work on what he called my "rodeo stuff."

I'd already shared dozens of the photos I'd taken at "renegade rodeos" with him and other fellow photographers. Renegade rodeos were how I referred to the rodeos that didn't fit the standard mold. Prison, police, kids, girls (yes, it *was* called "Girls Rodeo" back then), Indian (again, the official name of the Indian Rodeo Association), oldtimers, *charreadas*, and gay rodeos. I photographed them all. I even heard of a nudist rodeo. In California, naturally. But I never got close enough to that one to learn the true meaning of bareback riding. To say nothing of *rawhide*.

I was a highly unlikely candidate to fall under rodeo's spell. As a child of the military, the only livestock I'd encountered growing up came in shrink-wrapped packages from the base commissary. Part of the sport's appeal for me was the realization of how much the lives of rodeo competitors mirrored my own. I was attempting to support myself as a freelance writer, and the emphasis kept falling perilously closer to the "free" part of the description. Like the ropers and riders I photographed and interviewed, I was "going down the road," without a boss, a structure, or a guaranteed paycheck. *They* dreamed the next rodeo would pay off, would mark them as contenders, "real" cowboys. *I* prayed that whatever article or essay or story I was laboring over on spec would be accepted. That I'd have a payday and win the big buckle in my profession, a byline. That, God willing, I'd be able to pay my rent.

So I followed my fascinations and hunches about what might constitute a publishable story, and they led me to rodeos. My interest was not, primarily, in what happened in the arena. In fact, as an animal lover, I would have preferred that most of the actual events didn't take place at all. No, what intrigued me was witnessing how each group remade this most American, most mainstream, of pastimes in their own image. How they created distinct worlds that orbited the arenas on their own unique trajectories.

The ineffable qualities that made Black rodeos so much more compelling than the generic brand were on full display in the photo that Karl smuggled me into that UT darkroom to print. I'd shot the picture a few weeks before at a legendary venue for cowboys and cowgirls of color, the Diamond L Ranch and Arena. Once located on far South Main outside of Houston, the fabled Diamond L was the epicenter of the Gulf Coast rodeos I was concentrating on. As I sloshed the photo to and fro in the developer solution, ripples washed over the image that materialized in the reddish glow of the safelight. Like a corny effect in an old movie, they pulled me back in time, back to that sultry evening.

A night rodeo. A bronc ride.

The horse. A gleaming ripple of furious muscle, all four hooves off the ground.

The rider. A study in old-time rodeo cool.

Dressed in an immaculate white shirt, tie knotted at his collar and tucked into his pants, a stogie planted casually in his mouth and spurs raking the points of his mount's shoulders, he was leaning back easy as a kid on a rocking horse. I had frozen him in a moment of pure rodeo perfection, forever reaching his free hand out for what all rough stock riders are taught to reach for: a handful of sky.

I had expected Karl to notice the impossible stylishness of that bronc rider. Or at least to give me props for having the courage, or lack of common sense, to get into the arena with only a camera between me and nearly a ton of rampaging horse. Instead, Karl made that comment about the very existence of Black cowboys.

Karl's reaction was far from unique. The work I brought back from Black rodeos was generally received with mild surprise by my Austin grad school friends. Most were native Texans and had, undoubtedly, seen many Black cowboys; they just hadn't registered them as such.

The mainstream definition of cowboy was still a couple of years away from being stretched enough to include "urban" (which, in 1980, would

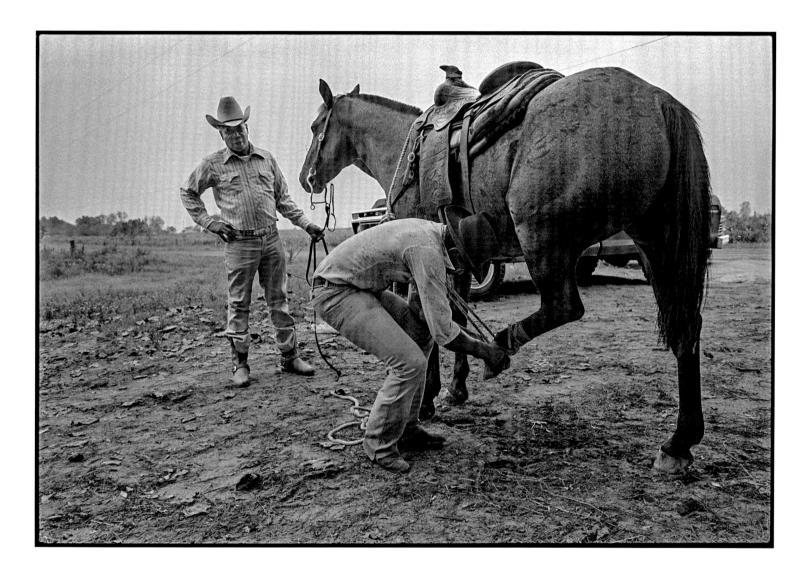

mean city boys like John Travolta, honky-tonking at Gilley's in Houston in the film *Urban Cowboy*). For several more decades, the species *Homo cowboyensis*—according to Hollywood and the popular history of that time—would still be required to have three defining characteristics: giant hat, boots, and white skin.

The general public was decades away from learning a few facts that are now common knowledge: enslaved people had worked livestock on all the vast ranches and plantations in Texas and other Confederate states, and roughly one-quarter of all the hands on the great cattle drives were Black. That ignorance was my rocket fuel.

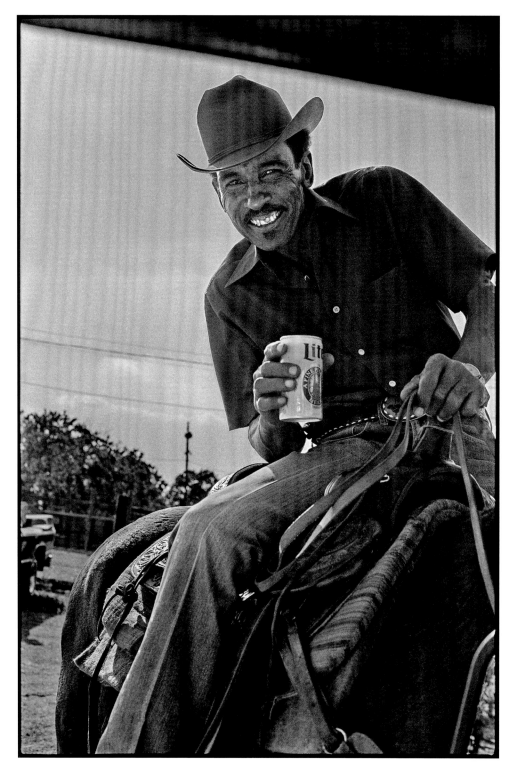

It was clear that the story of Black cowboys and cowgirls was a tale that had not been told. Clearly, their contributions, their heritage as westerners, their expertise with livestock, their very existence had gone unrecognized for far too long.

Thus, fired by a sense of urgency and convinced that Black buckaroos would be welcomed into the pantheon of western heroes the instant my photos were published, I made it my mission to shoot as many rodeos as my hobbled bank account and broken-down car would allow. (The vehicle in question was the highly dubious Chevy Vega, which Detroit initially heralded for its "revolutionary" aluminum alloy engine. I would learn, to my deep financial distress, that when the car's dashboard oil light came on, it didn't mean "time to change the oil," it meant "time to buy another revolutionary aluminum alloy engine.")

Certain I was on the brink of a major scoop, I ground out the miles, hitting every rodeo I could in tiny rural outposts like Egypt, El Campo, Pin Oak, Fresno, Sugarland, Spring, Kendleton, and Plum. Then I'd rush back to Austin with my canisters of undeveloped film. Unfortunately, by

1980, I no longer had friends allowing me to sneak into the UT darkroom. On top of that, a couple of the magazines I had been freelancing for went out of business without paying me, and I was forced to take a state job to afford groceries and photo supplies. For a year, I printed and submitted, sending off copies of my prize photos to publishers around the country. I waited for their enthusiastic acceptances.

They never arrived. Instead came various versions of the verdict, "There is no audience for a book like this." There isn't enough "interest in the topic."

I next turned to *Texas Monthly* magazine. Confident that they would be delighted to feature cowboys and cowgirls of the non-white persuasion in their pages, I submitted a proposal. In return, I received a rejection informing me that they already had a rodeo story in the works. When that article appeared many months later, it did not include a single cowboy or cowgirl of color. In short, the message from the publishing industry was: Black cowboys are an anomaly the country is, literally, not ready to see.

Tired of having both my heart and my bank account broken, I put my

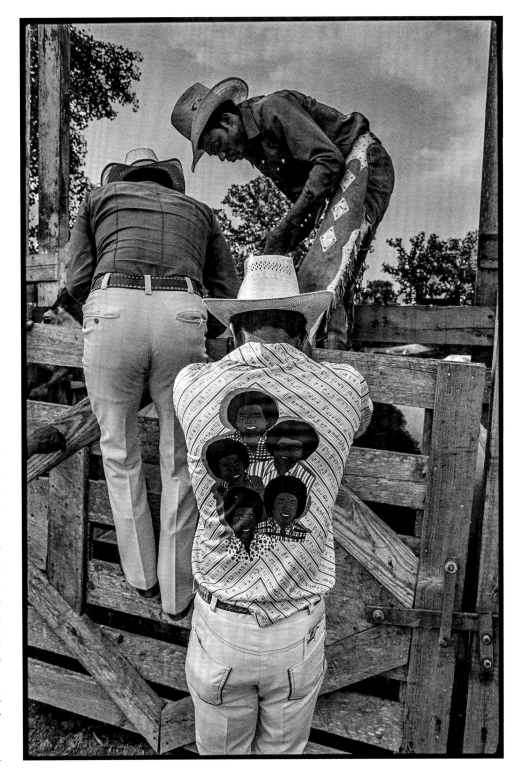

project aside. For more than forty years, those prints and negatives languished in boxes beneath my bed. And that is where they might have stayed—had it not been for a global pandemic.

Stuck at home, bleaching my groceries and worrying about exactly how long this plague was going to last and just how bad it might get, I suddenly had time to notice the appalling state of my dwelling. I briefly fell under the spell of Marie Kondo and set about the Sisyphean task of decluttering. My crowning pandemic achievement in this arena was alphabetizing the spice cabinet. All in all, it was a decidedly non-joy-sparking enterprise. Or it was, until I started poking through the fluffle—actual name for a bunch of rabbits—of dust bunnies beneath my bed and unearthed those boxes of rodeo prints and negatives.

In that moment, I accepted a few obvious realities: I would never again bask in the red glow of a darkroom safelight while sucking up toxic chemical fumes. Nor would I have to. For, during this project's Rip Van Winkle years, photography had gone digital.

In 2020, I donated all my prints and negatives to the Southwestern Writers Collection, where the peerless

archivist Carla Ellard and her team of wizards digitized my photos of Black rodeos. The files they returned to me came to life on the screen of my laptop like kidnapped children who had finally been ransomed.

Best of all, they could now be released into a world that is not only reclaiming the lost heritage of Black pioneers in the West but celebrating it. Gorgeous photo books, inspiring films, and widespread media coverage don't just acknowledge Black cowboys and cowgirls, they lionize them. From the Bill Pickett Invitational Rodeo that tours the country, to the stellar accomplishments of the many cowboys and cowgirls of color now competing in events sanctioned by the Professional Rodeo Cowboys Associations, the contemporary Black rodeo scene is thoroughly documented.

Sadly, such extensive documentation does not exist for the long years when the concept of a "Black cowboy" was an anomaly that, aside from a few notable exceptions, materialized neither on the screen nor on the page. It is that gap in the historical record that I hope this book fills. These images capture the final days of a time when the sport was still rooted in the business

of actual ranching; when many, if not most, of the competitors had grown up riding and roping; and when rodeo skills were honed not on the back of a mechanical bull but in the saddle of a horse the cowboys had most likely broken and trained themselves. I photographed men and women who knew how to rope, dope, brand, and dehorn a steer. It was a world that will never again have the same players or the same pressures and limitations that made these particular rodeos the most joyous, the finest of them all.

How can I make such an unequivocal statement?

My extensive visits to the many remote planets in the rodeo galaxy ultimately gave me something that was as valuable as a camera: a frame of reference that allowed me to know from the moment I experienced my first Black rodeo that they were unlike any of the others. My previous journeys are also important because they formed my thinking about the power and permutations of the cowboy identity. Each version of rodeo that I encountered illustrated a different facet of who the culture at large deemed deserving to bear that most masculine of American titles, and

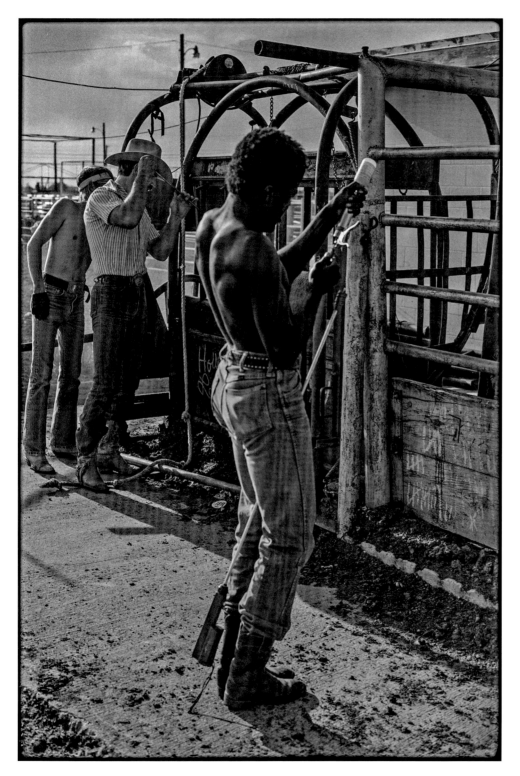

who was denied it. Taken together, they provided a basis for comparison that allowed me to appreciate the Black rodeos of the late seventies as the dynamic, the unique expression of a vibrant culture that they were.

# MY PATH TO BLACK RODEO
## CLOVIS LIVESTOCK AUCTION, 1976

Advertised through word of mouth and flyers, the small, nonprofessional rodeos I documented were nearly impossible for an outsider to track down. The only reliable sources of information I had were rodeo contractors and livestock handlers. One place to find both was livestock auctions. This photo, taken at the Clovis Livestock Auction early in my research, eventually became emblematic of my mission to understand and reframe the image of the Black cowboy. Though this wrangler isn't sporting a big hat and buckle, he is revealed to be the truest kind of cowboy: the kind who can not only rope a steer but also dope one (give him medication).

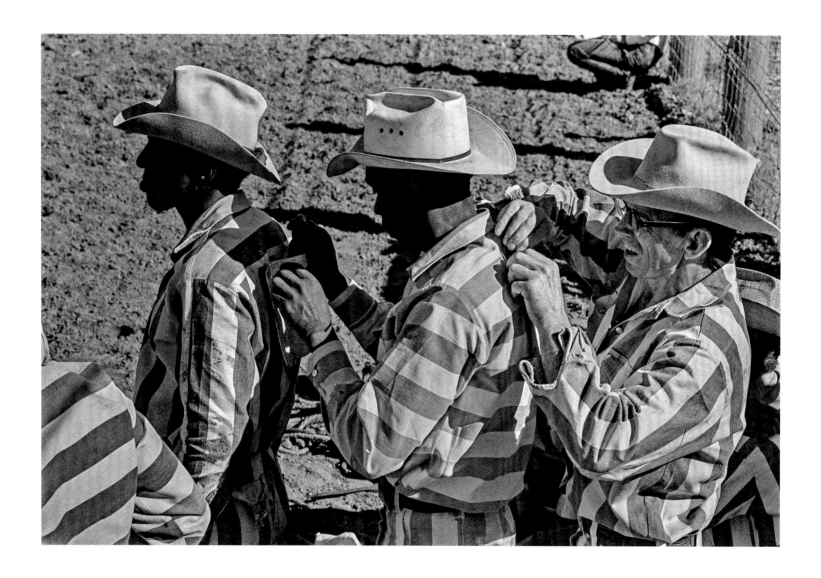

## HUNTSVILLE, 1976

It is a bitter irony that the first fully togged-out Black cowboys I saw after I moved to Texas were suited up in the complete western regalia of hat, boots, chaps, bandana, and spurs, but also sported one other striking wardrobe item: prison stripes.

This was prison rodeo in 1976 and, as *Ebony* magazine noted, "Contrary to customary practices in the Southland the Prison Rodeo is not a segregated competition and usually a fourth of the contestants are Negroes." As Mitchel P. Roth observed in his book *Convict Cowboys*, for many years prison rodeo was "the only com-

petitive sporting event in the South that wasn't segregated."

Given this rare opportunity to test their skills on something close to a level playing field, Black convict cowboys captured the coveted Top Hand Buckle a disproportionate number of times. By the 1970s the renowned O'Neal Browning had earned seven Top Hand Buckles. In 1976, I saw Willie Craig, a masterful Black cowboy with a resolute military bearing, win the All-Around prize at the mind-bendingly old age—for rodeo—of fifty-six.

## STAMFORD COWBOY REUNION, 1977

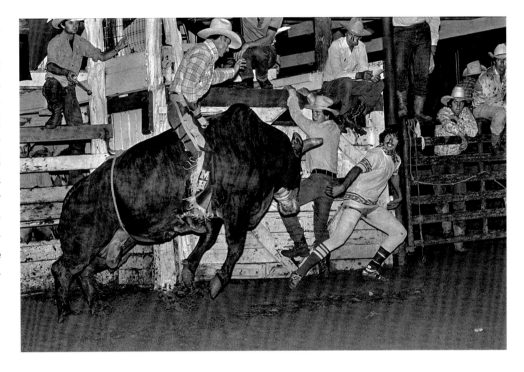

In 1977, the Stamford Cowboy Reunion was a living museum dedicated to the myth of how an all-white West was won the all-white way. Started in 1930, the Reunion, according to their current website, had "one aim of keeping alive the traditions of those that wrested this country from the Indians and the Buffalo." Among the first photos I snapped inside a rodeo arena, this one illustrates why the rodeo cowboy is an inheritor of a tradition that extends back to the bull-leaping Greeks of ancient Crete. As in those venerable ceremonies, rodeo is a demonstration and a celebration of man's sometimes tenuous mastery over the force and fury of nature. This raw potency is amply illustrated here by the massively equipped bull being symbolically conquered by the even more—we are to assume—virile rider.

The buckles, the big hats, and the boots symbolize this most masculine of victories. Though the contestants might work on construction crews and in oil refineries instead of on ranches, and might never touch a cow or a horse outside of a rodeo arena, they all thoroughly identified as, and were recognized as, cowboys.

## YOUTH RODEO FINALS (SNYDER, TEXAS), 1977

This dreamy, tousle-haired buckaroo and his mom embody for me one of the hallmarks of mainstream rodeo

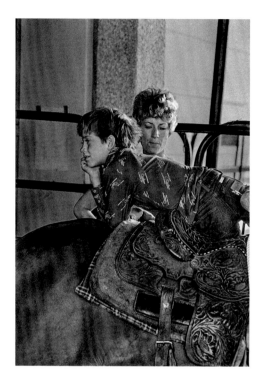

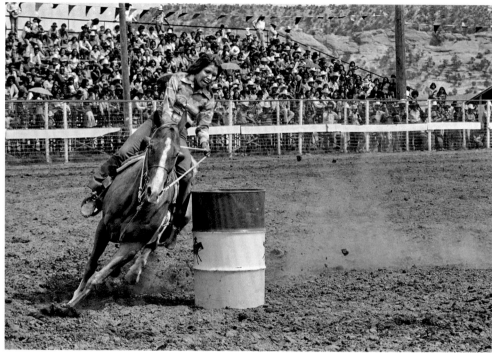

and rodeo cowboys: stoicism. The celebration of a grim-faced suppression of emotion permeates mainstream rodeo and is central to the cowboy mythos. As Mom was adjusting her son's stirrups in preparation for the grand entry, she told me a story about last year's finals. Her son had been competing in the calf riding when he got "thowed." She recounted how she'd known her child was injured when the boy didn't immediately jump to his feet. "There was something in his face that told me something was bad wrong."

But she'd taught the youngster never to show pain, or, really, any other emotion while still in the arena. Mama beamed with pride as she recounted the boy hobbling back behind the chutes where, out of sight of the crowd, he collapsed.

Only then did she "come to find out" that her son's leg was broken.

## NATIVE AMERICAN RODEOS, 1977

Back in the binary days of the 1970s, horsemen and horsewomen were neatly parceled into two categories: cowboy or Indian. No rodeos shed more light on the question of who had the right to bear the cowboy label than Native American rodeos. At Navajo Nation rodeos held in Gallup, Grants, and Shiprock, New Mexico, all the way up to Whiteriver, Arizona, where the White Mountain Apache Tribe hosted their annual tribal rodeo, I witnessed the superb roping and riding of Native cowboys and cowgirls.

"There's not enough water on the reservation for golf courses," a bronc rider in Gallup said, explaining their

skill with typical, dry Navajo wit, "so we rodeo." He went on to explain how a lack of traveling funds and training facilities kept most riders from "going down the road" in pursuit of the big bucks and bigger buckles.

A champion team roper in Whiteriver, Arizona, opined that he and his buddies preferred the collaborative effort of team roping over other events. He didn't feel the American competitive instinct was baked as deeply into him and his compadres. "When we go on the road," he added with a chuckle, "we always share everything. Even a toothbrush."

## GIRLS RODEO, 1977

Back in the late seventies when I was documenting renegade rodeos, the women's brand was still called "girls rodeo." It wouldn't be until 1981 that the Girls Rodeo Association would upgrade its name to the Women's Professional Rodeo. But were they cowboys? Though they roped and rode rough stock as well as or better than any fully fledged cowboy, did that qualify them to be taken seriously and accorded the same respect?

Not in the eyes of many a sniggering male spectator. I heard, "Ride the women!" shouted out by more than one beer-bellied wit watching from the bleachers—as if any of these tubby compadres were fit to touch the spur of Sue Pirtle.

When I photographed the twenty-four-year-old champion in 1977, Pirtle was still at the center of a firestorm of controversy for continuing to ride rough stock—bulls and broncs—into the eighth month of her pregnancy during the 1975 GRA finals. Though Pirtle considered those rides just another day on the job, the feat inspired many opinion pieces, a world of nasty letters, and the 1980 TV movie *Rodeo Queen*, starring Katharine Ross.

Pirtle, her healthy baby boy usually waiting in a playpen behind the chutes, would go on to win eleven World All-Around Cowgirl titles for roping and riding bulls and broncs. Try that, Beer Gut.

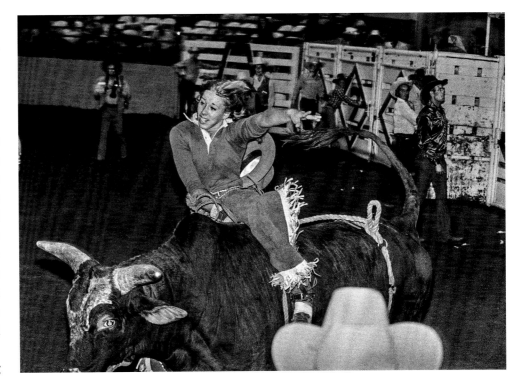

## CHARREADAS, 1975-1977

At the *charreadas* that I photographed in San Antonio, Sugarland, and along the border, it was clear that the first cowboys, *los vaqueros* and *los charros*, remained unequaled in the arena of equestrian skills. Along with dazzling costumes, I witnessed breathtaking displays of horsemanship and rodeo skills elevated to the level of dressage.

Impeccable dress was the rule rather than the flamboyant exception as the contestants competed in teams. Uniforms included the trademark sombrero, ties, sequined jackets, and trousers festooned with elaborate scrollwork. The events I photographed were so far removed from the hard-scrabble jeans-and-duct-taped-boots world of rodeo I'd grown accustomed to that they attained the level of pageantry. In *charreadas*, the role of "cowboy" is performed with an austere dignity and finesse that elevate the competitions to the level of ritual.

## GAY RODEOS

At the opposite end of the spectrum from the highly orchestrated *charreadas* are gay rodeos. The handful of rainbow rodeos I attended seemed more intent upon exploding the cowboy myth than enshrining it.

Though I was made to feel welcome, one of the organizers of a Dallas event, the first I attended, suggested that the participants, many from dangerously conservative small towns, would not appreciate being photographed. I honored that request and put my camera away.

"I grew up in a town you've never heard of," one bull rider said, his fire-engine-red wig askew and his makeup smeared. "And they'd never heard of gay. I never had a place back there. But this is my place right here," he added, straightening his wig before running off to join his choral group in a version of "Stand By Your Man" (which brought the house down).

You'll see many of the same events at a rainbow rodeo that you would at the straight variety. But expect a campy twist that livens them up.

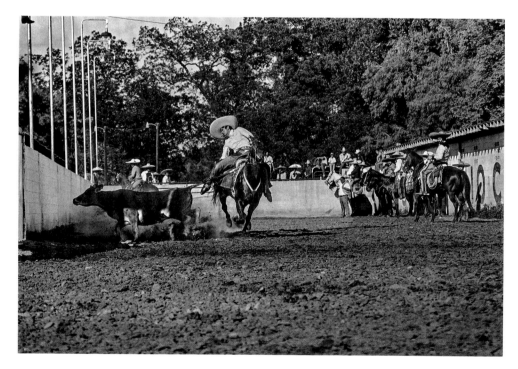

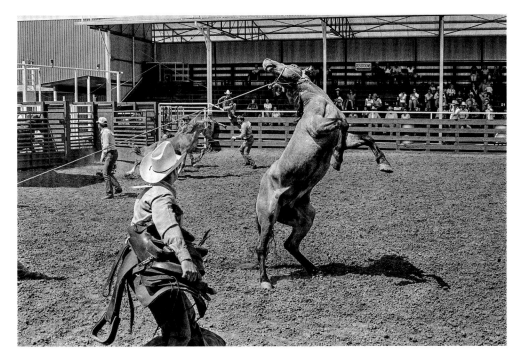
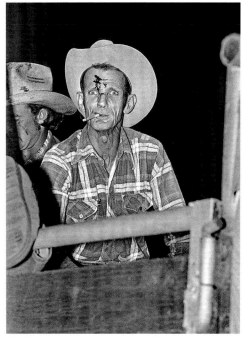

Livestock aren't always there to be roped or ridden. Sometimes they just need a makeover. Like the goats in the Goat Dressing event, where teams race to put a pair of tighty-whities on the nude quadrupeds.

I once asked a friend who occasionally accompanied me on my outings which type of rodeo he liked best. Without hesitation he answered, "Oh, the gay ones. No question."

"Why?"

"Because a guy in a peignoir never offered me a daiquiri in the men's room at any of the other ones."

Point taken.

## POLICE AND OLD-TIMERS RODEOS

Police rodeos? What can I say about police rodeos except that they are exactly like the standard brand—aside from the fact that the contestants can arrest you. Old-timers and police both proved themselves to be zealous guardians of a status quo that placed them squarely on top as the only true inheritors of the cowboy mantle.

I don't think I truly understood the power of the cowboy myth until I shot several old-timers' rodeos. Despite having a few artificial joints and bones

as brittle as peppermint sticks, these superannuated buckaroos happily strapped on the spurs and climbed aboard a ton or so of hooved animal for one more chance at eight seconds of glory: one more chance to win that big buckle that renewed their right to call themselves "cowboy."

From cowgeezers to convict champions, all the renegade rodeo riders and ropers contributed both to my understanding of the power of that title and ultimately to the unfairness of it ever being denied to Black cowboys. And now, let's get back to the center of the frame.

# "LET'S GO! LET'S SHOW! LET'S RODEO!"

All the myths and misconceptions of the late 1970s that excluded Black ropers and riders from bearing the vaunted title of cowboy would have been exploded had the doubters attended even one rodeo on what was known as the Soul Circuit. And had that one rodeo been a Juneteenth rodeo, those delusions would have been utterly atomized. By the late 1970s, dozens of Juneteenth celebrations were being held within the 250-mile radius of Houston that delineated the heart of Black Texas rodeo. Over the summers that I photographed these rodeos, my untrusty Vega and I traveled to as many shows as that revolutionary aluminum engine would allow.

Formed by the burdens and limitations of de facto segregation and still rooted in ranching and agriculture—where "cowboying" was both a verb and a way of life— that precise world has now all but vanished. This section hopes to share with the reader a sense of why it was so extraordinary by recreating a composite of a day at a Black rodeo. And not just any rodeo on any day: a Juneteenth rodeo.

Pictures and words can never fully capture the essence of a small-town 1970s Juneteenth rodeo. They were multisensory experiences that started early in the morning, before any hoofed or hatted competitors arrived, and lasted long into the night, when the jubilation spilled over into nearby honky-tonks and bars.

Though there never were "typical" Black rodeos and it would be impossible to describe a "typical" day at one, common threads ran through them all. Using these threads, I have attempted to stitch all the photos taken at many times and at many venues over several years into a luminous quilt that represents one perfect day at one ideal Juneteenth rodeo, in a world where joy was the ultimate triumph.

## A DAY AT A JUNETEENTH RODEO

Our day starts early with the arrival of the all-important pit master. Long before the first fan arrives, in the cool of the early morning, he's there, firing up his smoker. Smell: that's the first sense a Juneteenth rodeo engages. Imagine being greeted by the mouthwatering aroma of meat slowly smoking over post oak, maybe some tangy mesquite. That fragrance goes a long way toward creating the party vibe that thrums throughout the day.

By the time the pickups and cars are backing up to the arena fence, clouds of barbecue bliss are wafting toward the arena. Passengers hop out, eager for what Juneteenth promises just as prominently as rodeo, and that is reunion. For many, the holiday marks an opportunity for a parade of former residents to come home from the Big City—usually Houston—to the rural communities where they'd grown up. Returning friends and relatives are welcomed back into the fold. Festive clusters form around the open bed of a pickup, a camper. Lawn chairs are popped open and bottles passed around as everyone catches up on the

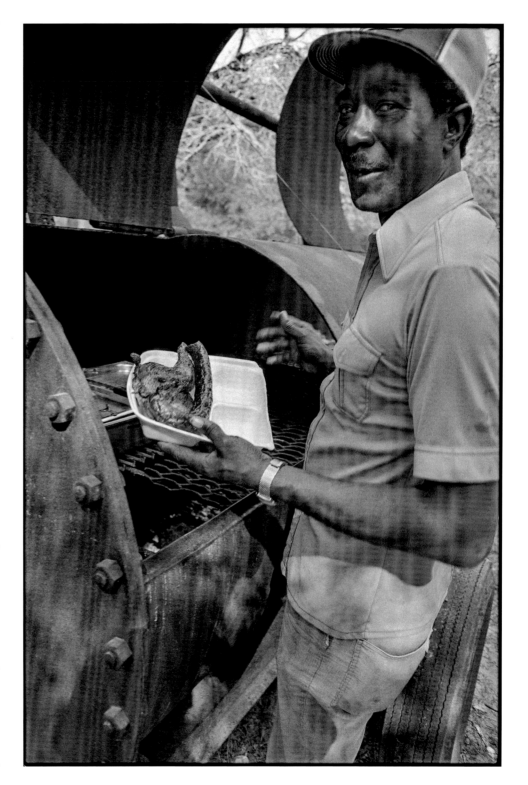

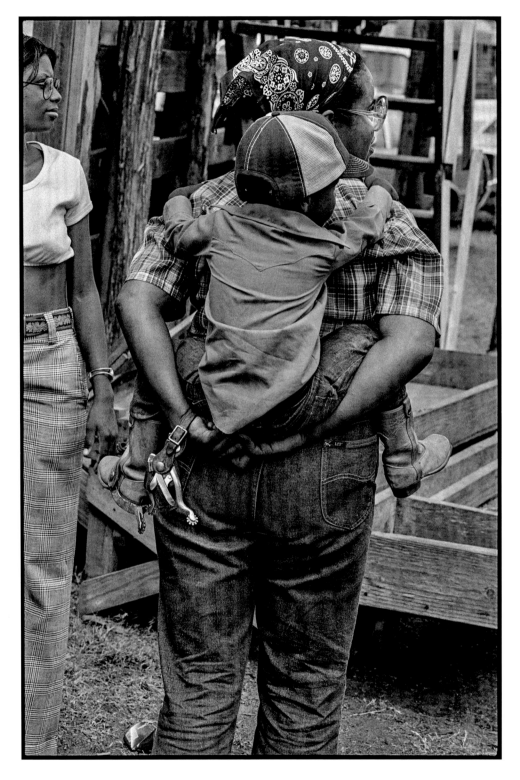

latest news. The buzz of happy conversation fills the air, already warming as the sun climbs higher.

With the adults' attention on renewing old friendships, the cowkids cook up their own fun. Long before the livestock ever shows up, there is roping. So much roping. The baby buckaroos, dreaming their own cowboy dreams, follow their spinning lassos wherever they lead. Little dudes with little lariats scramble through the crowd, roping anything that moves: dogs, chickens, horses, little sisters. A particularly well-aimed loop once captured my ankle when I was hurrying to catch a shot of two girls who'd ridden their swayback horse to the rodeo. Fortunately, the junior roper was only practicing breakaway, not tie-down. Other kids—kids with more sanctified aims—run the gauntlet of lassos intent upon their mission of selling jumbo bars of chocolate for Ebenezer Baptist or the local AME church.

Floating above the rattle of well-loved pickups, delighted greetings, kids hawking chocolate bars, the nickering of horses, the protests of animals being herded into holding pens, and the call and response of a good gossip session is the one sound that

most defined and separated Black rodeos from all the others: laughter.

The big-hearted, open-mouthed laughter that erupts spontaneously and flows effortlessly seems to power another characteristic of Black rodeo that is as essential as it is endearing: hospitality. Virtually everyone I ever encountered at the rodeos seemed guided by the Bible's admonition to welcome strangers, with the extraordinary incentive that "for by so doing some have unwittingly entertained angels." Their unquestioning friendliness was all the more remarkable when contrasted with the generally chilly reception, or outright exclusion, that Black rodeo-goers would have received at white rodeos in the area at that time.

By midmorning, a deep-throated, earth-shaking rumble and growl announces the arrival of the stock contractor's semitrailers. The opposing team has arrived. The air brakes hiss, the mammoth vehicles shudder and then are still. The sudden silence is filled by the bellowing of the dogging steers and roping calves, the snorting of bucking broncs, and thundering clangs as the bulls slam against the metal walls of the livestock trailer.

As the livestock is unloaded and the sun reaches its zenith, an idea ripples through the crowd: lunch. The party shifts toward the concession stand, where everyone is eager to see if the pit master has outdone himself. One bite of brisket sandwich confirms that he certainly has. Of course, a cold drink is required to wash down that fork-tender brisket: Big Red, RC CoCola, and Golden Age orange soda for the kids, and for the grown-ups, Schlitz, Falstaff, and the most festive of all Black rodeo bevs, Champale.

As if to second the toasts being raised around the arena, a loudspeaker nailed to a nearby pole crackles to life. At my first Black rodeo, expecting the mournful country and western laments delivered in a requisite twang that make up the inevitable soundtrack of most rodeos I'd attended, I couldn't suppress a grin when a bass line as irresistible as it was unmistakable followed some well-timed cowbells to introduce the disco funk hit "Boogie Fever."

"Buh-buh-buh, boogie fever." Yes, indeed, a quick glance at all the shoulders bobbing rhythmically and heads nodding in time assured me that the crowd was happily obeying the song's

command to "get on down, get on down." For getting a party vibe going, it beat George Jones keening about the guy who "stopped loving her today" all to heck.

The easygoing, movable-feast quality of Black rodeos highlights another big difference between them and the standard variety. I recall many a mainstream rodeo announcer kicking things off by promising the audience, "We got a good show, a fast show. We'll have you out of here on time." Those rodeos were tight and they were, indeed, run rigidly on time. In contrast, Black rodeos exuded a looseness that left room for solidifying old friendships and laying the foundations for new ones. I never saw a printed schedule at any Black rodeo I attended. No matter how late the events started, the fans had a good time before the show started, continued to have a good time during the rodeo, and generally had an even better time when the whole affair was over.

The tempo does pick up, though, when the rodeo secretary arrives to start registering contestants for the day's events. If the rodeo was held at the Diamond L Arena, it was almost guaranteed that Gladys Carr, the

Queen Bee herself, as she was known, would be graciously carrying out secretarial duties. She would sign up all comers, collect their entry fees, issue contestant numbers, and perform the all-important "draws" for the rough stock riders. Draws are the process of matching cowboy with bronc or bull, some quadruped with a name like Terminator, Gravedigger, Widowmaker, or Cuddles. (Okay, maybe not Cuddles.)

After being issued their contestant numbers and learning which animal they've been matched with, cowboys cluster together to help each other pin numbers onto their backs and compare draws. Those who've been assigned "dinks" moan that they'll never earn winning scores on such low-energy mounts. The few who've drawn a "spinner," a "slinger," a "chute fighter," or any other fearsome "rank crusher" put on a brave face as they collect sympathy and tips from other cowboys about how to ride the possibly unrideable animal—the one that might put a horn or a hoof where it shouldn't be put.

The bleachers fill up. Down in the arena, the ballet starts. Rough stock riders work out muscles that have been confined in the cab of a truck for too long. Bronc and bull riders bend over to loosen up back muscles that are soon to be mercilessly whiplashed. Arms are pulled to the side to stretch the shoulder muscles that a horse or bull will soon attempt to jerk from their sockets. The riders "rosin up their riggins'," tugging ferociously on the braided ropes that will, with any luck, keep them attached to their draw. The ropers limber up the tools of their trade, slinging lassos as freely as their pint-sized imitators. The lone bleacher is packed and the crowd senses that, at long last, the show is about to begin. Drawing from my transcripts and notes taken at many events, I'd like to recreate that indelible moment when an unforgettable announcer takes over and a rodeo becomes a "show."

But first, a word about that man—and it always was a man—who determined the tone and pace of the show, the announcer. A few were soft-spoken, dry, and unemotional. They stuck to the facts, calling out the order in which ropers and riders would compete, then letting us know how each one scored. An unforgettable announcer, though, was a flamboyant showman who made the whole affair vastly more entertaining. But even the most dazzling announcer could never steal the show from the fans. At the liveliest rodeos there was always a back and forth between the crowd, the announcer, and the competitors. Those were the ones where I took the most notes, made the most recordings.

From those notes and recordings, taken at many different rodeos, featuring many different announcers, I've created a composite announcer of the more entertaining variety. In this passage, he's working a show that is also a composite of many shows, in a town that we'll call Jordan. The richness and humor of the exchanges, the vibrancy of the country phrasing, are all taken verbatim from rodeos I documented, and no writer could improve upon them.

Imagine, then, that we are sitting with the expectant crowd, shading our eyes with an upheld hand, waiting for the rodeo to start, and the PA crackles and squawks. The music stops. The soundtrack of laughter, conversation, and the noise of kids playing subsides.

The announcer commandeers the

microphone and booms out, "Let's go! Let's show! Let's ro-day-OH!"

The crowd whoops out their exuberant agreement and we are off!

"Welcome, welcome, welcome! Ladies and gentlemen! This is Derrick 'Dynamite' Barnett, your announcer for the Annual Jordan Juneteenth Rodeo!

"We're coming to you today with a good show, a fast show.

"Bronc riders!" Dynamite calls out. "Be getting your minds on it, now, y'all hear, because those broncs be planning on a late summer and an early fall!"

The announcer scores his first laugh with the well-worn line.

Out in the arena, up near the chutes—amid the scrum of a dozen or so competitors—a couple of would-be bronc riders, two teenagers from the Houston suburbs, hold each other's cigarette as they pin contestant numbers to one another's back. One wears a finely woven straw hat snugged down close on his short hair. The other has a knitted Rasta cap pulled over dreadlocks. An old-timer at least three times the boys' ages, calmly smoking a cigar and wearing a tie, of all things, looks on.

A cloud of dust roils up as the stock

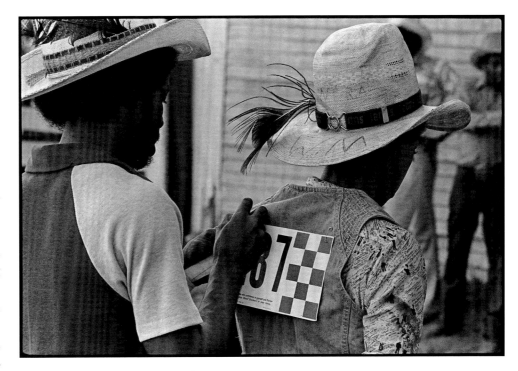

handler, armed with a cattle prod, drives the bareback broncs into the loading chutes, yelling, "Sixty-five, load up there! Move, sixty-five! Move! Sixty-seven, you move too! Forty-three, quit lookin' at me that way and do what I say!"

The young cowboys grow silent as the snorting horses are prodded in. The first cowboy in line solemnly straps a pair of spurs on boots held together by duct tape as he dreams of winning that big, shiny buckle.

"Now, ladies and gentlemen," Dynamite continues, "this is where the pavement ends and the West begins! Fans, fasten your eyes on Chute Number Three. Our first rider today is Kevin Caldwell."

One of the teenagers glances up. He looks like a man about to be dropped behind enemy lines.

"Kevin coming to us from Houston, Texas. Houston, Texas! His folks's all from Jordan. They've been many a fine Caldwell rider; we'll see if Kevin

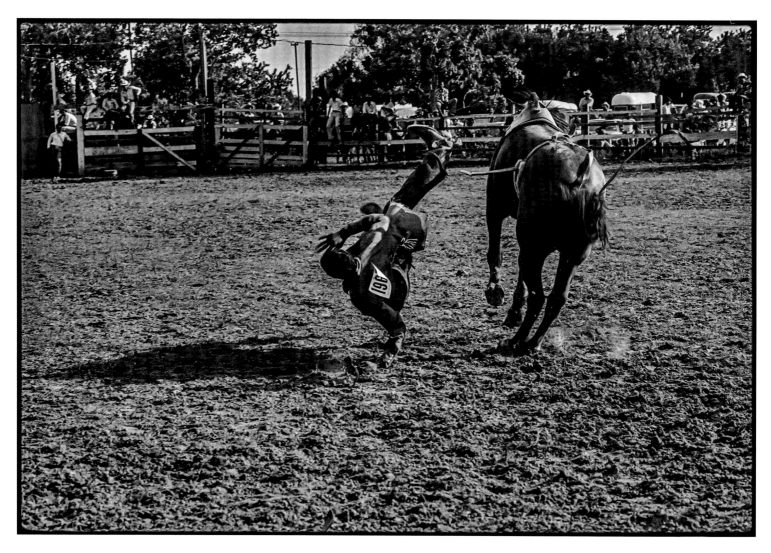

has any of the good genes. He's on the rank horse, Banana Split! Okay, Kevin, let's go! Let's show! Let's ro-day-OH!"

Kevin lowers his lanky frame down onto Banana Split's back and scrunches up against the hand he's dug deep under the bareback rigging.

The Caldwell family honor hangs in the balance. Kevin jams his hat down until his ears flap out. He sets his face in a determined expression, tenses every muscle in his young body, and gravely nods, signaling for the gate to be swung open.

Banana Split glances out at the open arena and freezes. Kevin Caldwell, rigid with fear, does not move either. A quick jolt from the stock handler's hotshot, however, inspires Banana Split to make a lunge for freedom, and poor Kevin is toppled off.

"Ooo-WEEE! Ole Kevin got his banana split for sure!"

The crowd comes alive, hooting and catcalling as Kevin dusts off his hat and runs for the chutes.

"Next outta chute . . . ? Which chute that? Chute Four! Chute Four! A handsome cowboy from down around Plum way, Hush Aldine!"

Hush Aldine, a short, chubby man, looks like a mushroom in cowboy boots. A woman wearing gold metallic loafers and a halter top stands up and yells, "Hush, I paid two dollars to see you ride! I be talking about you, you don't!"

Though he appears not to have a neck, Hush swivels his head in the woman's direction and yells back, "Why own't you air out! You loud enough to be twins!"

The crowd whoops, and bottles from every direction are passed to the woman. Hush settles down onto the bronc and nods. The gate swings open and his mount breaks for daylight. Once out of the chute, though, all the spirit drains from the beast and he delivers a ride that would have had a three-year-old at the machine in front of a Walmart demanding a refund. But it is enough to dislodge Hush, who

drops gently onto the freshly plowed earth.

"You let that dink fro you!" the woman in the gold loafers yells, and the crowd hoots with her.

Hush slowly gets to his feet, wobbles for a moment, then drops back down to his knees, doubled over, clutching his chest as if the crushed pack of cigarettes in his breast pocket were a vital organ.

"Faker!" the woman jeers, and the crowd merrily joins in. "Faker! Faker! Faker!"

Hush flips them off and leaves the arena.

"Hot to go in Chute Number Two! Junior Cantrell on Midnight! This bad bronc don't know the meaning of the word CO-operation!"

The old-timer is up. Moving like a Zen master presiding over a tea ceremony, Junior tucks his black tie into his waistband and sets the butt of his cigar in the corner of his mouth. Finally, he lowers himself onto the coal-black horse's back and says softly to the gate tenders, "Turn him out, boys."

Junior marks his bronc out like a stop-action photo of perfect rodeo form: free hand held aloft, both his dull spurs planted high in the beast's

shoulders. Midnight has all four hooves off the ground, back bowed into a shuddering arc. The horse hits the earth, and Junior takes the shock with the nonchalance of a man getting comfortable in a rocking chair.

"Style her, baby!" a voice from the suddenly silent crowd rings out. "Style her!"

Junior rocks casually through the rest of his eight seconds. The worst that Midnight can do is to pull Junior's tie loose from his waistband. When the horn blares, Junior slides off his mount's back before the pickup men can reach him. Taking no notice of the inept riders thundering around him in pursuit of the bronc they've let escape, the skilled veteran flicks a few stray horse hairs from his shiny chaps, smooths his tie back down, and takes a deep draw on his cigar.

When Junior removes the stogie from his lips and puffs out a perfect ring, the crowd, consecrated by the sheer loveliness of what it has witnessed, becomes a unified whole, clapping and hollering its approval.

"Cold! Cold! Cold!" Dynamite warbles. "That's Junior Cantrell showing y'all how the tale is told, how the bronc was rode. Don't ever count these

old men out! They'll show you evva time! Evva time!"

Did you guess that the mystery bronc rider I photographed inspired Junior Cantrell's majestic ride on Midnight? Well, you are correct. Go collect your buckle.

Other riders, other events follow: calf roping, both tie-down and breakaway; the sole women's event, barrel racing; bareback; maybe some saddle bronc riding; and steer wrestling, once more popularly known as bulldogging.

Steer wrestling is worth commenting on, both because I witnessed some championship runs and because it was invented by the legendary Black cowboy and Wild West show performer Bill Pickett. Also, as crazy as most rodeo events are—climb aboard a homicidal bull? I think not. Steer wrestling represents another dimension of insanity.

Many count this event as the most dangerous in a flamboyantly dangerous sport. It's certainly the fastest, with the world record currently sitting at 2.4 seconds. Basically, the event consists of two riders channeling a careening steer between them. The "hazer" on the animal's right keeps the steer on a straight course,

while the contestant on the left sidles up alongside the crazed animal and jumps on its head. You heard that right. The cowboy, thundering along at thirty-five miles an hour, simply leaps off his horse, gets the steer in a hammerlock, sets his boot heels, and attempts to wrestle a 500-pound bovine brute into submission.

After all the death-defying action, it's time for a breather.

## RUFUS GREEN SR., THE GODFATHER OF BLACK RODEO

*White boys turned rodeo into work.*
*We had fun.*
*We always had fun.*
**—RUFUS GREEN SR., 1923–1982**

At a few of the rodeos I attended, there would be a moment halfway through the show devoted to honoring a member of this tight-knit community who'd passed on during the previous year.

On this, our imaginary day at a "typical" Juneteenth rodeo, I'd like to remember Rufus Green Sr. It was my great good fortune to meet Green and to become one of the lucky ones

the renowned horseman took under his wing.

Green earned the title the Godfather of Black Rodeo as much for his majestic spirit and benevolent mentorship of a couple of generations of champion ropers as for his phenomenal roping skills and for being one of the first Black cowboys to cross the color line, earning membership in the Professional Rodeo Cowboys Association. Like the other true, ranch-raised, old-school cowboys I met, Green had a soft-spoken, courtly manner. He was quick to laugh, slow to anger, and, as Green's close friend Monroe Lawson said, "He was incomparable in his disposition."

He was certainly incomparable in his hospitality, allowing me to spend a couple of days with him at his home in Hempstead, where I was privileged to watch his gentle way of training both young horses and young ropers. One memorable Sunday, Green invited me to join him for lunch. He held the restaurant door open, and we stepped into what was obviously the after-church lunch spot for most of Hempstead. Conversation stopped dead and all eyes swiveled my way. I was used to this reaction. It had

happened at every small-town Dairy Queen and country diner I'd set foot in on my travels. I was a stranger, and a 5-foot, 10-inch unaccompanied female one at that. Stares were to be expected.

But this scrutiny was different. The glances skittered off me and focused on Green. That's when I noticed there wasn't another Black face in the room. The hostess, along with most everyone else, seemed frozen, gazes ping-ponging from Green to me, trying to make the two of us add up. Then Green, in his quietly forceful way, stuck his hand out to a rancher sitting at a nearby table, greeted him by name, and they shook. The spell was broken. The film reel that had frozen started up again, and we were shown to a fine table with Green shaking hands all the way.

The incident recalled a couple of poignant memories Green shared with me in the lengthy interviews we conducted, memories that had to do with other tables, other meals. When I listened to my ancient tapes for the first time in over four decades, I heard Green's soft, butter-on-biscuits voice again as he told the story of the first rodeo he'd competed in at the tender age of twelve.

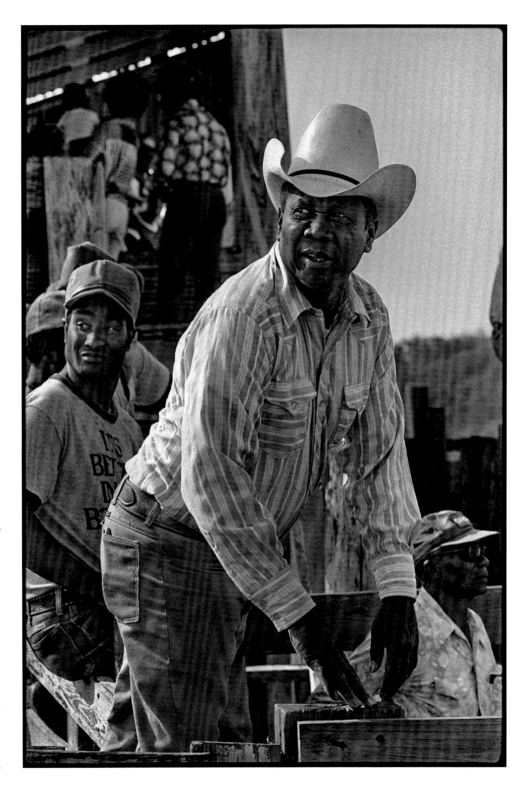

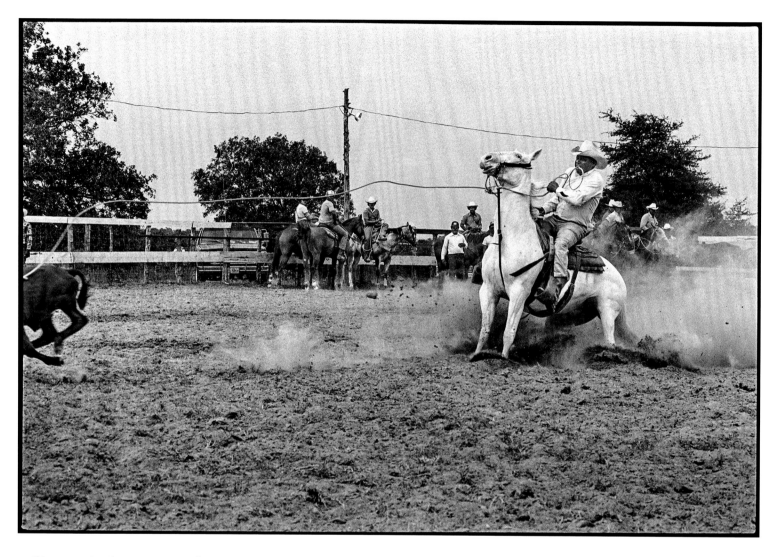

"I was raised on a cotton farm and next door, a man had a cotton farm. He gave ten cents for each row of cotton you picked. Those rows were over a mile long. I earned five dollar from Monday through Friday.

"The next Sunday everyone was going to Sunday school and as we walk along, my cousin come along with his horse and trailer going to the rodeo, so I flagged him down. When we reached the rodeo ground, the guy at the gate didn't charge me because I was so small. When I rode into the roping box, everybody got up on the cars because it was their first time seeing a roper that small. I roped my calf in three seconds and won eighty-five dollars. Good Lord, that was quite a lot of money for a twelve-year-old boy to be packing around after dark."

The ancient tape purrs with Green's soft laugh as he concludes, "So I've been rodeoing ever since because it's easier rodeoing than picking cotton."

Green's roping skills were to change his life dramatically when, at the age of fifteen, they attracted the attention of F. W. Gross of Victoria, Texas. Upon witnessing the diminutive teen catch half a dozen calves the white rancher's own hands couldn't rope, Green recalls Gross exclaiming: "'Guy dog, this boy can rope!' You know. He say, 'I got two daughters. I'd give my right arm to have a boy like you. How about coming to live with me?'

"I say, 'I don't know.'

"He say, 'You got any more brothers, sisters?'

"I got nine brothers. Nine boys with me. And I got five sisters.

"How your daddy feed all y'all?" This was '39. Times were hard. Gross said, "I'd still like to take you home with me. How 'bout I ask your daddy can you go live with me? I'll be just like your daddy to you."

Back home, Green shared the proposal with one of his sisters, who told him, "You know mama ain't gonna let you go stay with no white folk, you crazy?"

Green recalled how he had emphasized the opportunities that awaited when he told his parents, "Well, they say Victoria is [like] the city of Rome. More millionaires lived there than anywhere in Texas."

The next week when the family went into the nearby town of Edna to "make groceries," Green's father met with Gross.

"I had all my clothes in a flour sack," Green recalls. Standing close enough to eavesdrop on the men's conversation, Green heard Gross promise that if Rufus wasn't happy and didn't want to stay, he'd bring him home. The two men shook hands to seal the deal, and the arrangement, unthinkable to us now, was made.

Fortunately, Gross was as good as his word. Green recalls coming down to breakfast the first morning and being surprised that Mrs. Gross greeted him with a handshake.

"Back then, you know, white people didn't shake your hand. She said, 'Sit down. What you like for breakfast?'

"Over where I come from, the Black man'd sit at another table. They didn't eat together. So I got my plate and went to sit at a little ole table they had

and she said, 'Naw, you sit here, eat with us. You're our son now.'"

Though Green was a "son," he wasn't sent to school and worked full-time as a ranch hand. But the teen was delighted with a new life that included shopping in the finest stores in Victoria for clothes, ordering custom-made boots, and eating with the family in the best restaurants.

Over the coming years, Green developed into an acclaimed horse trainer, trader, and roper. Equipped with both unparalleled roping skills and a rare knowledge of how to navigate the white world, Green became one of a vanishingly few Black cowboys who were full-time rodeo professionals in the mid-1950s.

"Back then," Green explained, "the Black cowboys never could rodeo with the whites in the South. So we'd all go back East, back West, all around Mexico. But all back up in these parts, it was rough. You had to rope after the rodeo or early in the morning before the people got there."

Green never allowed such injustices to slow him down. Over his career, he competed in more than two thousand rodeos. He was a founding member of the historically Black Southwestern

Rodeo Cowboys Association; one of the first Black cowboys to be awarded membership in the Professional Rodeo Cowboys Association; and, at a time long before Black people were even allowed seats at the Houston Fat Stock Show, Green was the first African American to compete in calf roping. He placed second in tie-down.

After recounting all the awards and honors and history-making firsts, Green concluded with a story about being in a town in Oklahoma where "there weren't any Blacks at all. They were so rough you had to put on the jacket." (A jacket with the Flying A brand on it indicated that the wearer was part of Gene Autry's rodeo.) "If you had a Flying A across your chest or on the sleeve of your Levi's jacket, you could go in a place and they let you come in and eat. But if you didn't have that jacket on, you better not let sundown catch you."

In Green's sweet-tempered voice, I heard pride as he told the story of lingering with his buddies outside a downtown restaurant until a waitress caught sight of their jackets.

"Oh, man," he recounted, "when she saw that Flying A, she *begged* us to come in. She fixed a *nice* table for us to eat."

It was the accounts of those two meals—one in Victoria, one in Oklahoma—that tugged at my memory. That current of pride connected them with our lunch in Hempstead when, once again, using the stealth battering rams of his easy manner and majestic kindness, Green cleared the way for us to be seated at a *nice* table amid all the church-going white folk.

A seat at the table.

That was all he or any of the Black cowboys had ever asked for.

## NIGHT RODEO

Did I say daytime Black rodeos were jubilant, friendship-fueled affairs? Try a night rodeo. Because when the sun went down, the good times went up. Magic always seemed to happen once the arena lights were switched on.

In the cool of the evening, bottles are passed around even more freely. The cowgirls grow more irresistible and the cowboys even more appealing. Bets about which rider will hang on past the eight-second buzzer, or which roper is going to get the job done fastest, are made and shaken on. A game of dice might start in the beam of a truck's headlights. The betting accel-

erates to the tempo set by the cracking dice. As the action in and out of the arena heats up, the line between the two blurs, then dissolves completely. Fans climb into the ring to share their opinions on exactly how lame the last rider was and how much better they could have done.

At one unforgettable night rodeo, I was treated to a spontaneous a cappela performance of "Me and Mrs. Jones," sung basso profundo to a woman—Missus, Missus, Jones?—in the stands, who covered her face with her hands. That might have been the same show that was interrupted so that a runaway bronc could be captured. In response, easily half the crowd flooded into the ring to dance on the plowed earth or to simply mill about, claiming the stage as their own.

The grand finale event is always bull riding, where all comers try out skills that the younger, city-raised hopefuls are likely to have developed on the back of a beast powered by electricity rather than by grass and grain. The drama of watching both veterans and newbies go head-to-head with a behemoth weighing between seventeen hundred and twenty-two hundred pounds is undeniable.

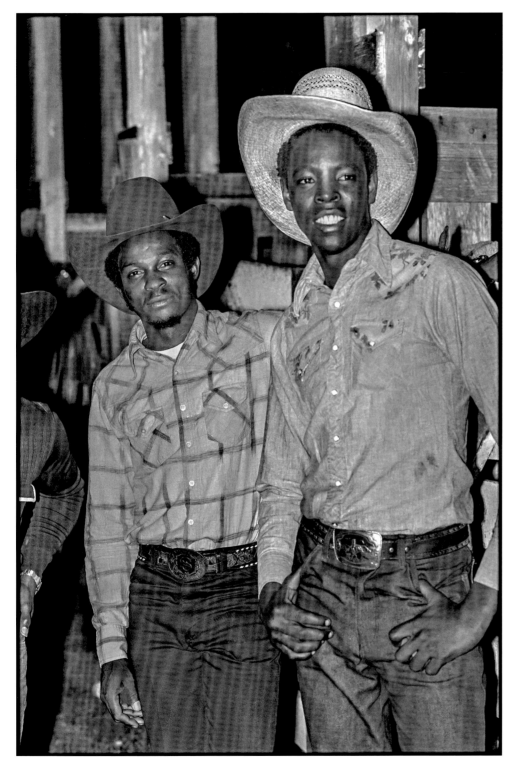

The gate is flung open. The bull explodes out. The rider atop this tornado of muscle is ragdolled around, usually for only a few seconds, before being hammered into the dirt. Occasionally, a rider will make it to the eight-second buzzer. Let's say that on our imaginary day at the perfect Juneteenth rodeo, one such glorious ride closes out the action.

Time now for the judges and rodeo secretary to go to work. The finer points of rides ridden, steers wrestled, and calves roped are dissected and argued over—frequently with vociferous input from some of the old hands. Once the scores are settled upon and added up, the announcer will proclaim that day's winners, and those much-coveted buckles, trophies, and even saddles will be awarded.

A great night rodeo always closes out at the nearest watering hole, so that thirsts of all sorts might be quenched. The favorite venue after an event at the Diamond L is the nearby Blue Lagoon Saloon, where a giant dill pickle from the jar on the counter costs a quarter. Where the cigarillo choices are Roi-Tan, El Producto, or Prince Edward. Where the gold Christmas tinsel on the ceiling wafts

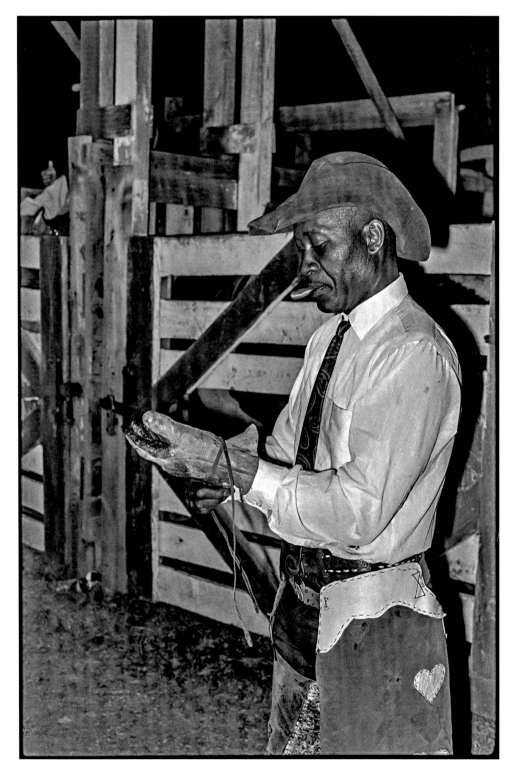

in the air-conditioner breeze all year round. Where the Schlitz is always icy cold and the music blazing hot. Where all the broncs and bulls are ridden again, all the calves roped, steers wrestled, and barrels raced. Where everyone did it exactly right and won the biggest trophy and everyone goes home with the prettiest cowgirl and the handsomest cowboy.

All that remains now of this perfect day at a Juneteenth rodeo is to emblazon the trophies with the champions' names.

Names.

## DIAMOND L ARENA, HOUSTON, SUMMER 1978

I return again to the debonair bronc rider: the one who baffled Karl and ignited my quest.

Who was he?

Who was the dashing cowboy I'd captured mastering a bucking bronco with stogie, tie, immaculate white shirt, and dignity all intact?

Nearly half a century after that muggy night at the Diamond L, I scrutinized the photo I'd taken of him tugging on his riding glove. I zoomed in on

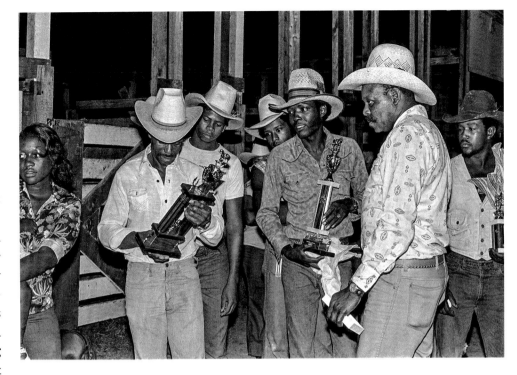

his face, as resolute and calm as that of any warrior preparing for a battle he knew he would win.

Who was he?

Though I had a certain memory that he was a skilled rider and, obviously, wildly photogenic, I could not recall his name or find it in my notes. For help in identifying him—and as many of the rest of my subjects as I could—I turned to Larry Callies, an expert so knowledgeable and so committed to telling this untold tale that, using his own savings, he founded the Black Cowboy Museum in Rosenberg. From Callies I learned that the dapper bronc rider who'd started it all was a legend. Though he was christened Taylor Hall Jr., all his cowboy friends and fans knew him as Bailey's Prairie Kid. And there were a lot of friends and fans.

Born in the little farming community of Bailey's Prairie in 1932, Hall was raised on a horse and was capturing rodeo buckles with ferocious regularity by the age of sixteen. As real a cowboy as ever sat a saddle, The Kid is an inductee into the Texas Rodeo Cowboy Hall of Fame, the Cowboys of Color Hall of Fame at the National Multicultural Western Heritage Museum in Fort Worth, and the Bull

Riders Hall of Fame. It was a stroke of luck that I preserved this icon of skill and style—in and out of the arena—on one of the final prize-winning rides of his storied career. A few years later, at the age of fifty, he retired from a sport that considers a thirty-year-old to be dangerously geriatric.

The discovery that I'd captured a legend in action made me even more eager to learn as many names as I could. Though dubious about how tech-savvy my subjects—many now in their seventies and eighties—might be, I nonetheless turned to social media. On Facebook and Instagram pages for Black cowboys—Black Cowboy Events, Horses, Tack & More; the

Black Cowboy Museum; the Black Professional Cowboys and Cowgirls Association; the National Multicultural Western Heritage Museum; Black Trail Riders; and many others—I posted my photos and asked for help in identifying the cowboys and cowgirls and their fans.

To my surprise, within days, I started hearing first from relatives and then from the actual subjects of my photos.

"That's me," Randy McCullough, who'd contacted me by phone, said. He drew my attention to a jubilant photo in which several champions compare trophies. "In the vest and black hat," McCullough clarified.

McCullough, an award-winning

veteran of the Soul Circuit, was a gold mine of information, and he shared it generously. He seemed to have known, and even better *remembered*, nearly everyone in my photos. I could barely keep up as he reeled off names, nicknames—Dynamite, Blue, Skeet, Bo Pink—and anecdotes that brought all those formerly nameless faces to bright and vivid life. Among those he identified was a fellow bull and bronc rider, Archie Wycoff.

The name sounded familiar. A bit of Googling revealed I'd seen it in the credits for the 1972 documentary *Black Rodeo: No One Ever Told You There Were Black Cowboys*. A champion bull rider, Wycoff, along with Muhammad Ali and Woody Strode, was featured in the film, shot at a rodeo held in Harlem.

Another milestone was connecting with one of the preeminent historians of the reclaimed heritage of Black cowboys in the West, University of Houston professor Demetrius Pearson. Pearson literally wrote the book on our shared field of interest with his 2021 publication *Black Rodeo in the Texas Gulf Coast Region: Charcoal in the Ashes*. Along with his friend,

renowned cowboy Harold Cash, Pearson verified most of the names I'd gathered, and, with the patient exactitude of the scholar that he is, added many more. He provided the name of one especially electrifying possibility, the most celebrated Black rodeo cowboy of all: Myrtis Dightman.

Excited that I might have captured the Jackie Robinson of rodeo, I consulted with Christian Wallace. Wallace, author of a superb *Texas Monthly* article on Dightman, confirmed that the first African American to compete as a National Finals Rodeo contestant and one of the very few of any race to be a finalist seven times, and also the man whose name and face was on the T-shirts worn by fans in several of my images—Myrtis Dightman himself—was in not one, not two, but *four* of my photos.

I'd considered one of those images to be a sad mistake: it was the last shot on the roll and a third of it is chopped off. It was destined for the cutting room floor until I found out that the jaunty cowboy at its center was none other than the trailblazing National Rodeo Hall of Fame icon. Not only is Dightman standing in front

of a fan wearing a Myrtis Dightman T-shirt, but the man himself appears to be reaching into another dimension, let's say the future, to touch the next generation of cow-heroes. Or, in this lucky case, cow-heroines.

Green, Hall, Wycoff, and now Dightman? What incredible beginner's luck I'd had in immortalizing four legends of Black rodeo. But, as exciting as it was to have champions and legends in the collection, they were no more essential to creating the atmosphere of festive jubilance that I'd sought to capture than the kids selling candy, the rodeo secretary registering entrants, the fans cheering and heckling, that award-winning pit master, or the hapless rider who got dumped on his bad luck right out of the gate.

In rodeo, it's all about the buckle. The silent testimony—no brag, just fact—that the wearer is a champion. Let this book, then, be a giant, gleaming buckle awarded to all those pictured within, because long before the rest of America started to get their history right, these images put Black cowboys and girls where they always belonged: joyfully, triumphantly smack-dab at the center of the frame.

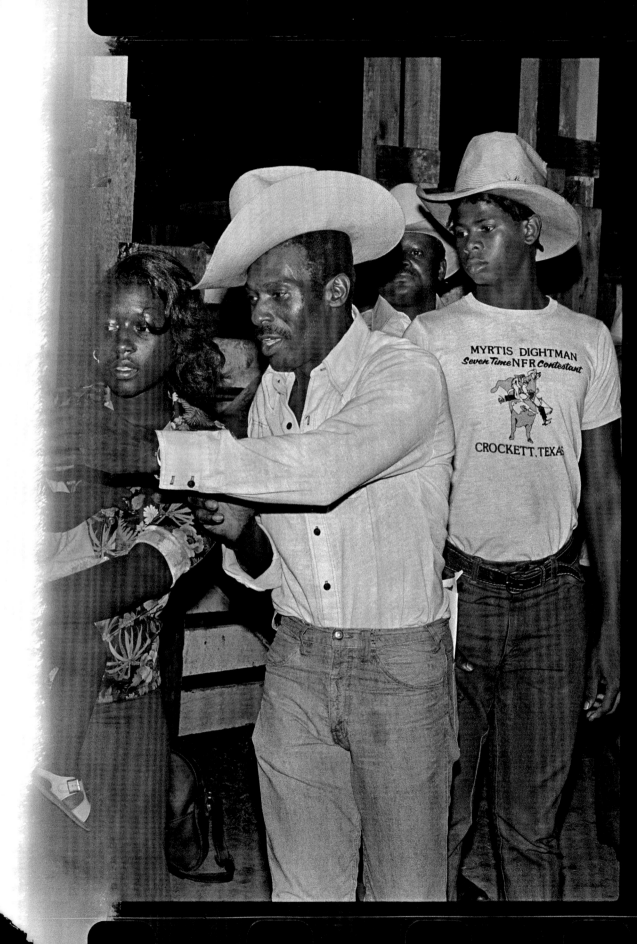

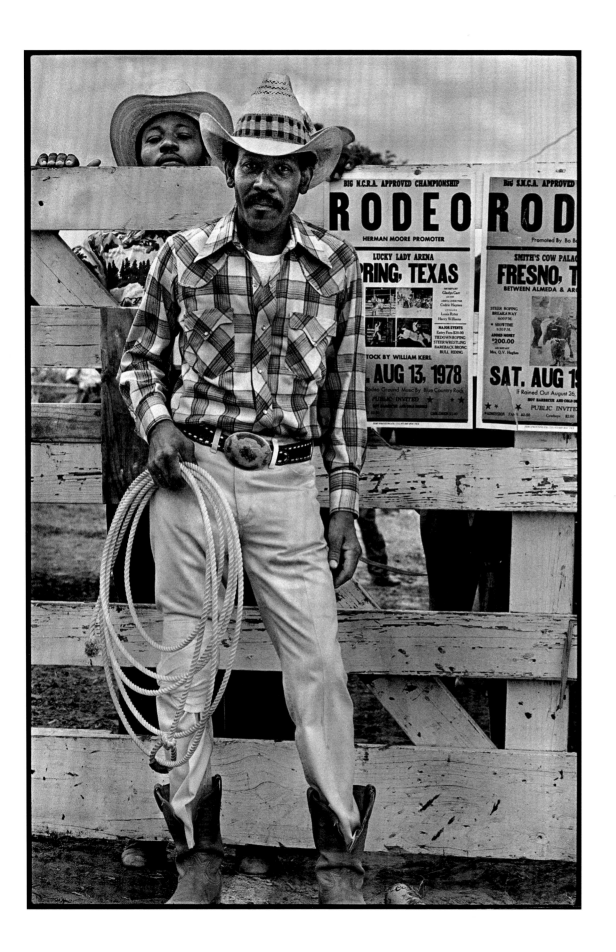

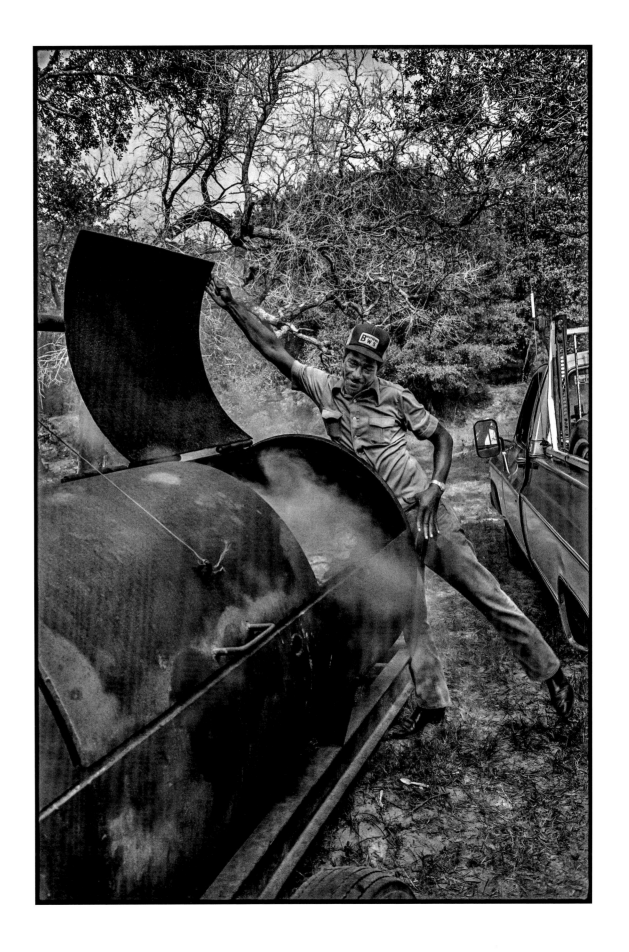

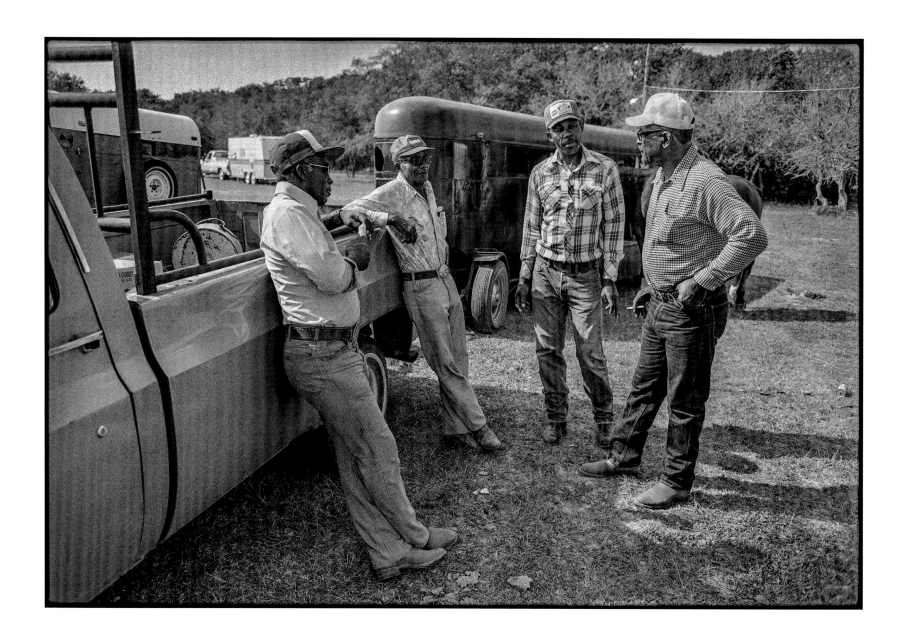

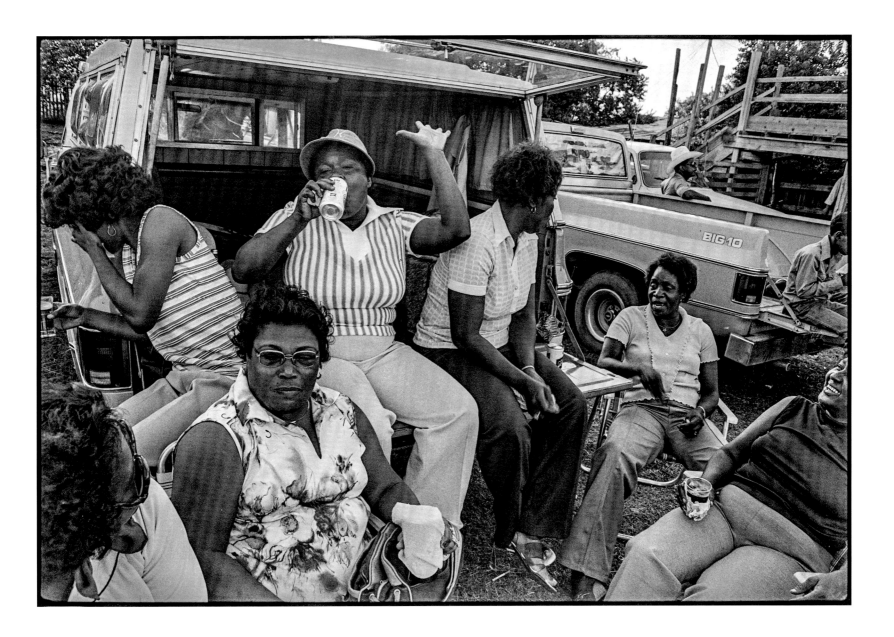

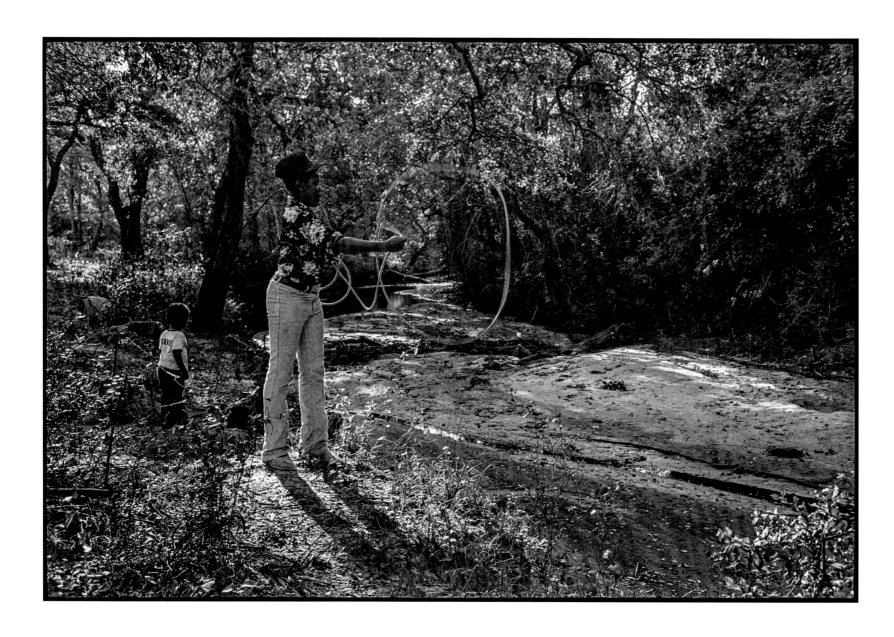

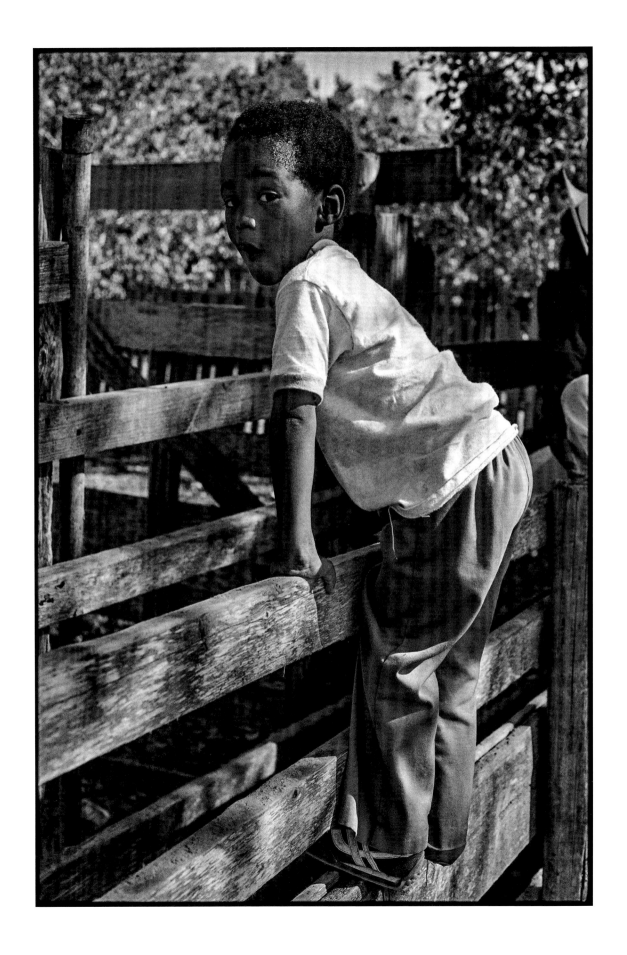

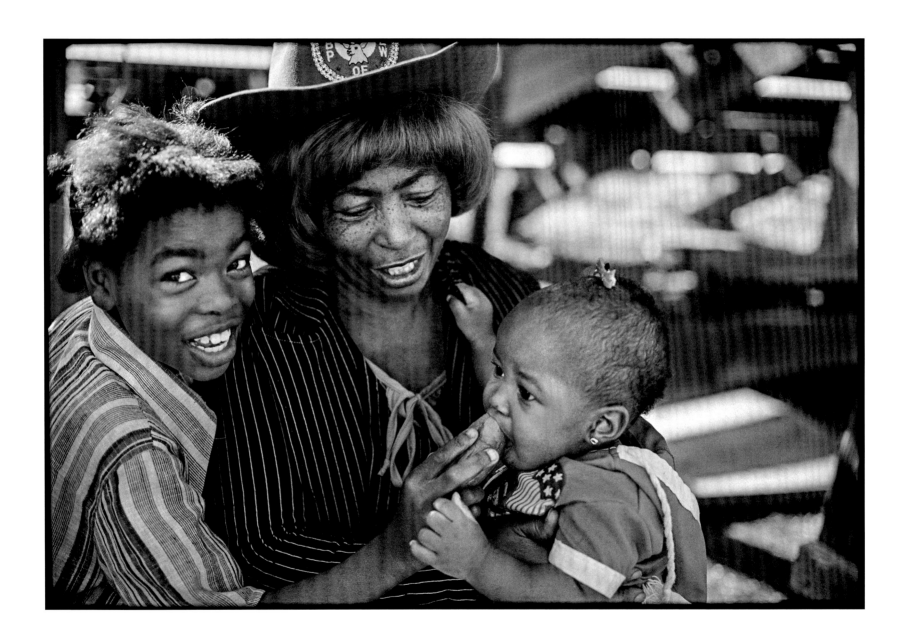

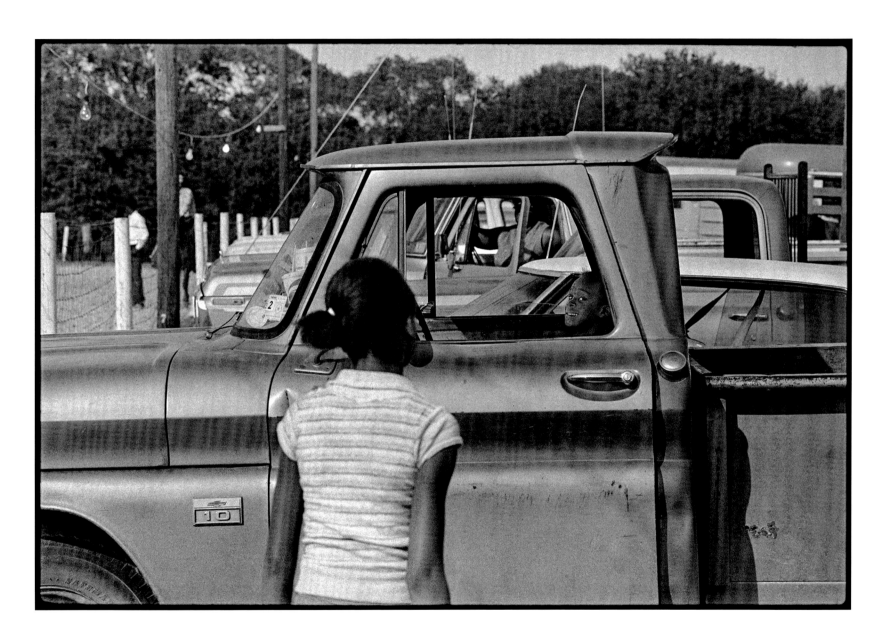

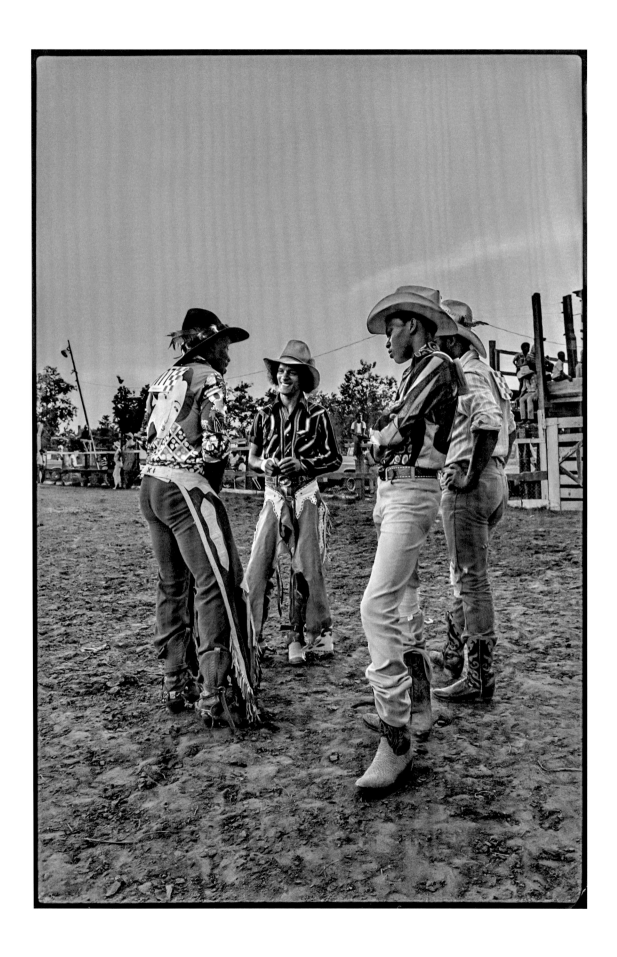

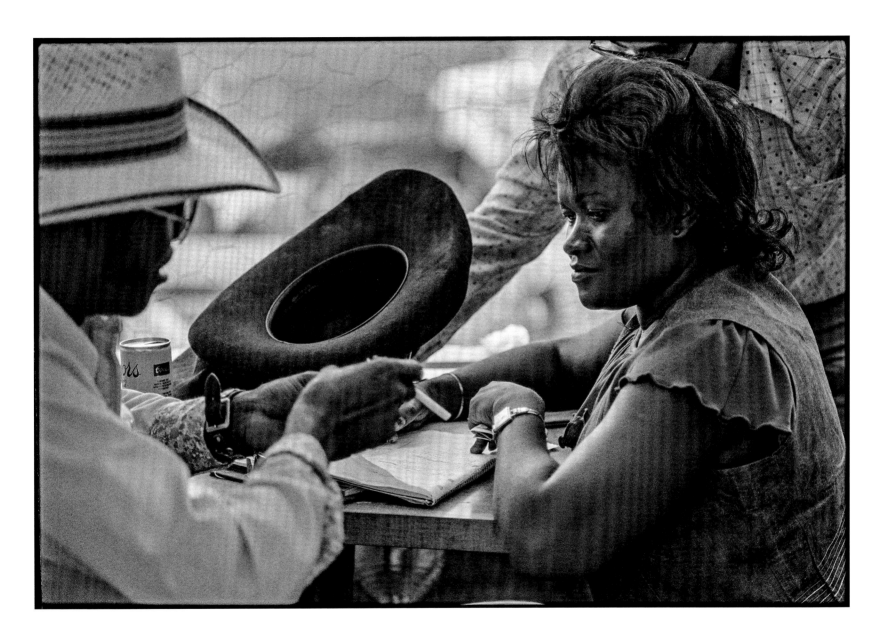

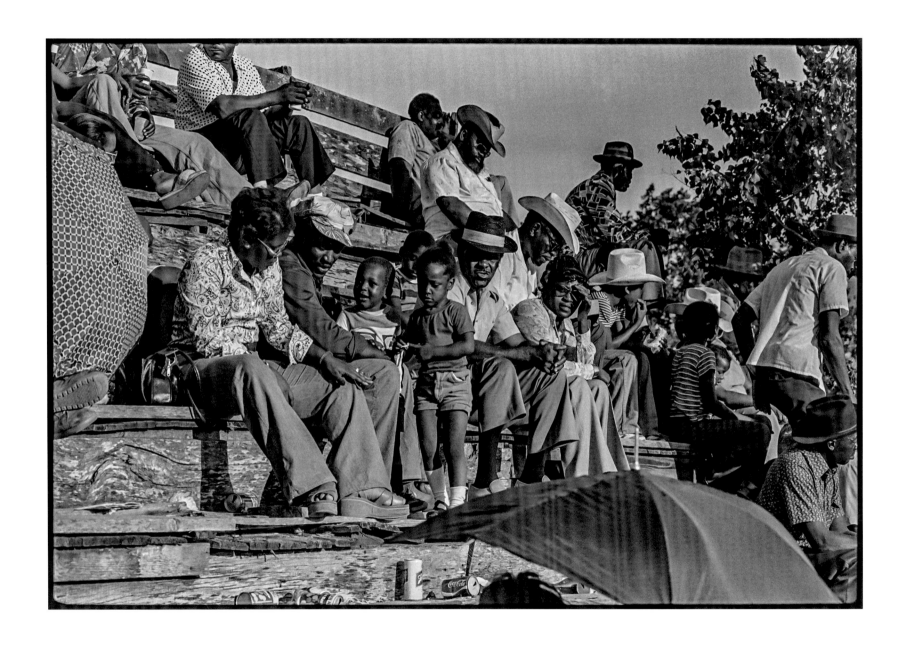

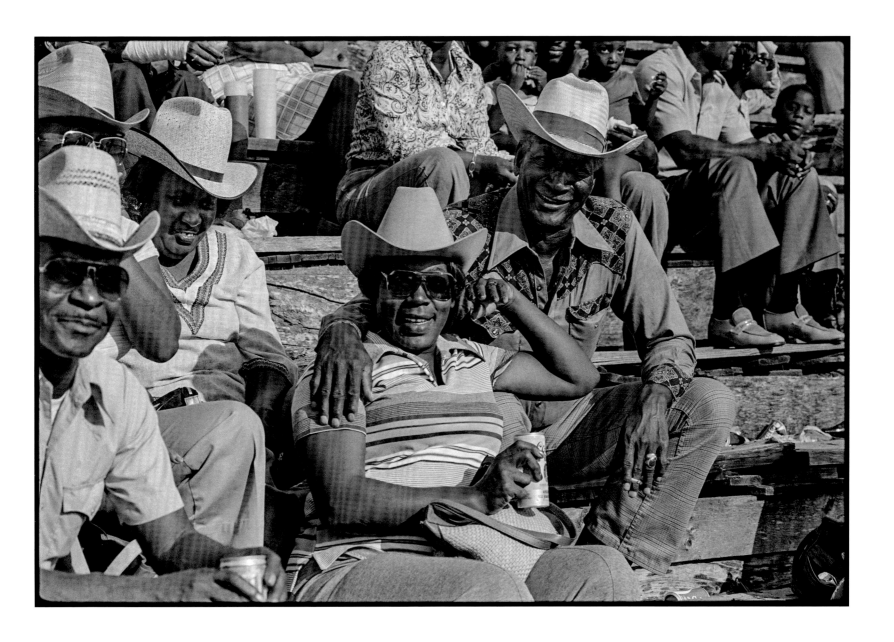

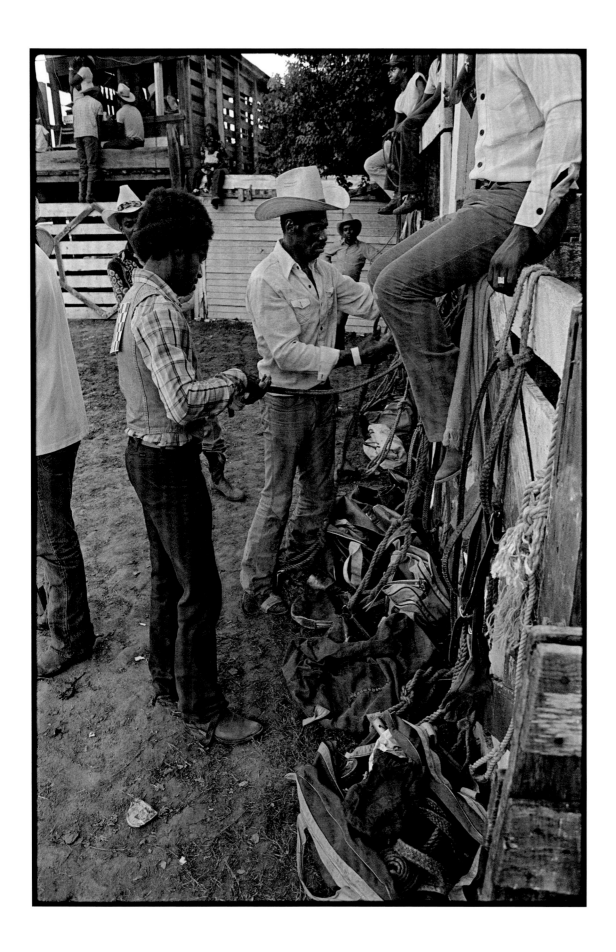

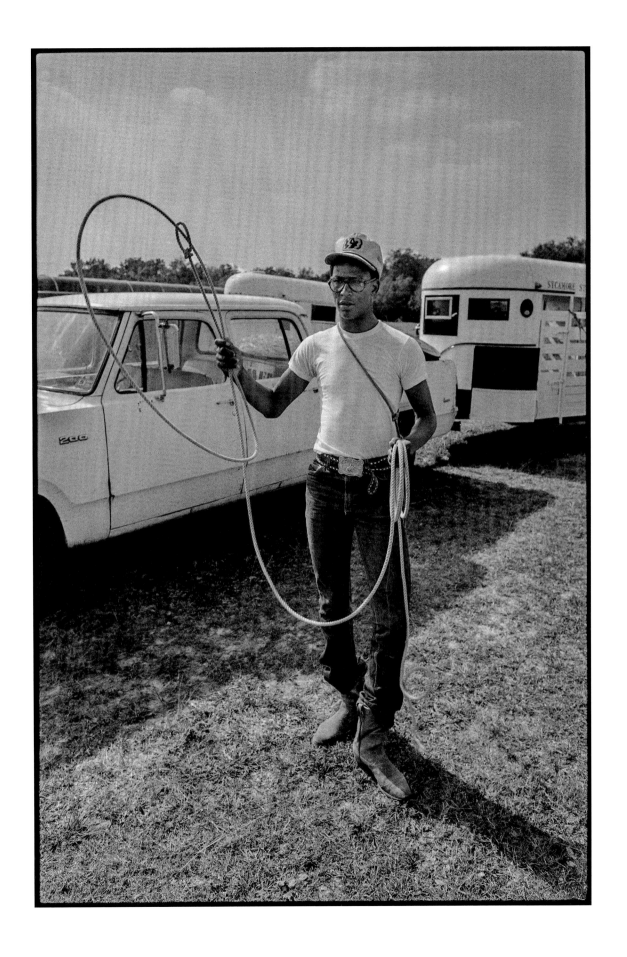

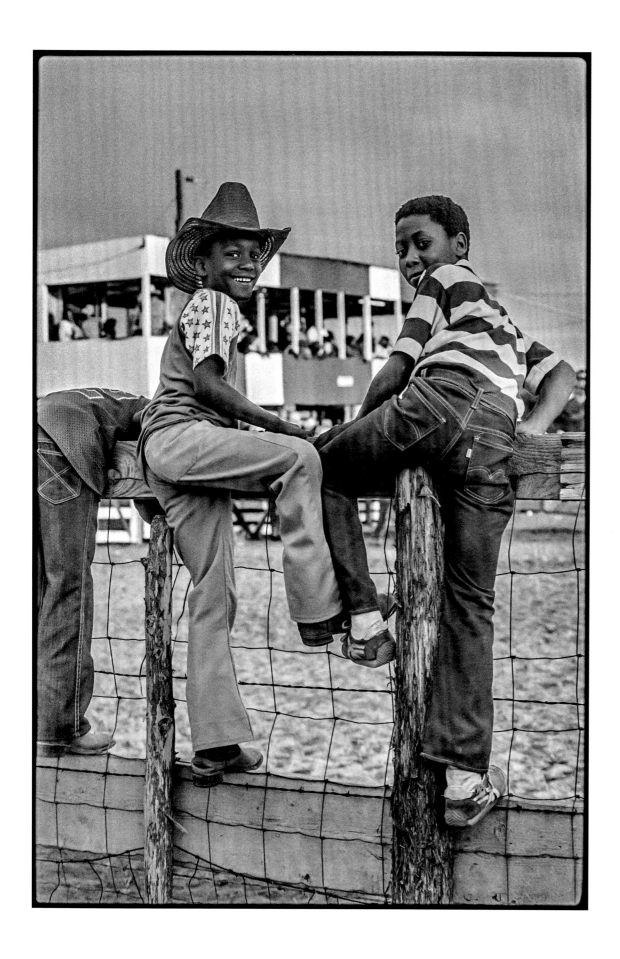

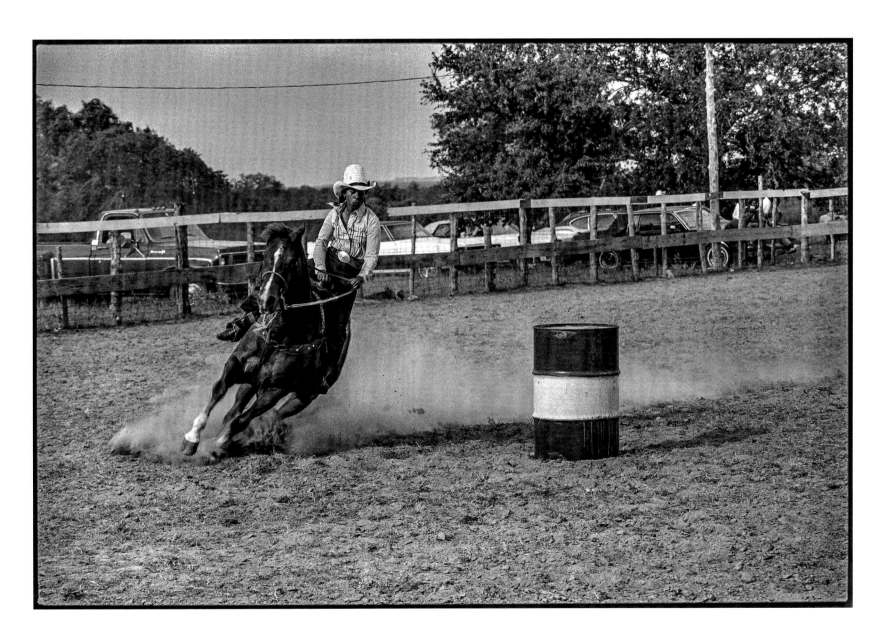

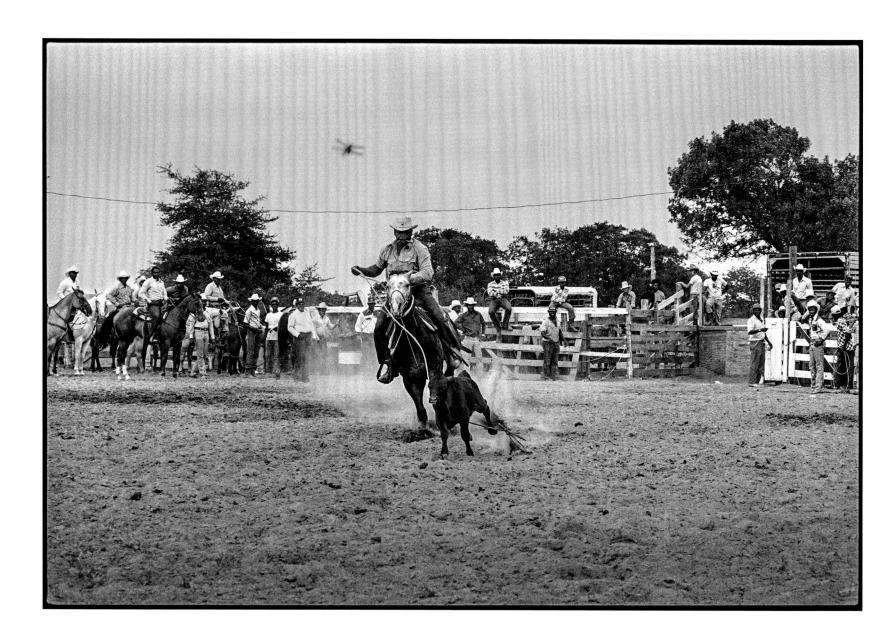

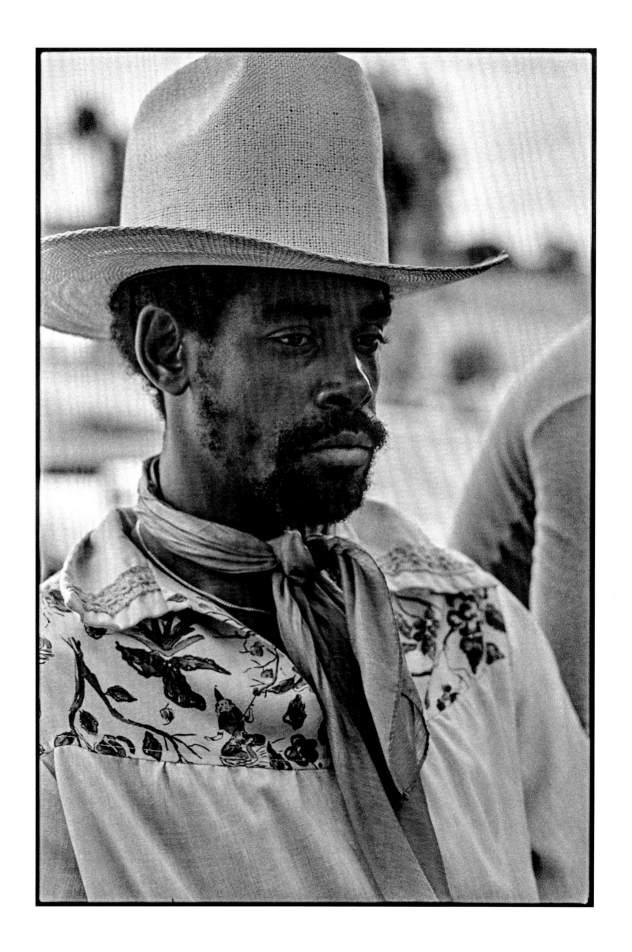

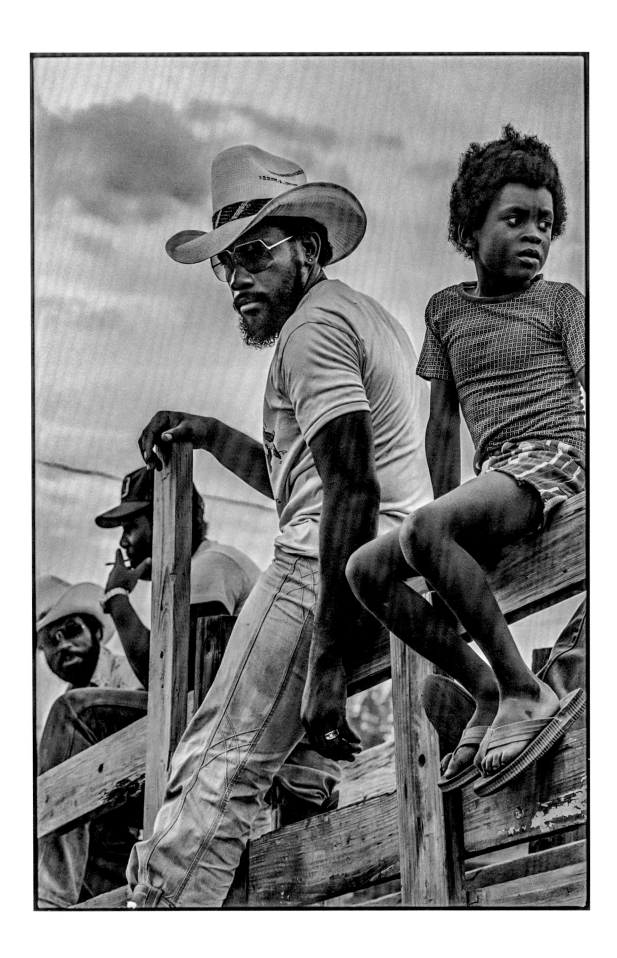

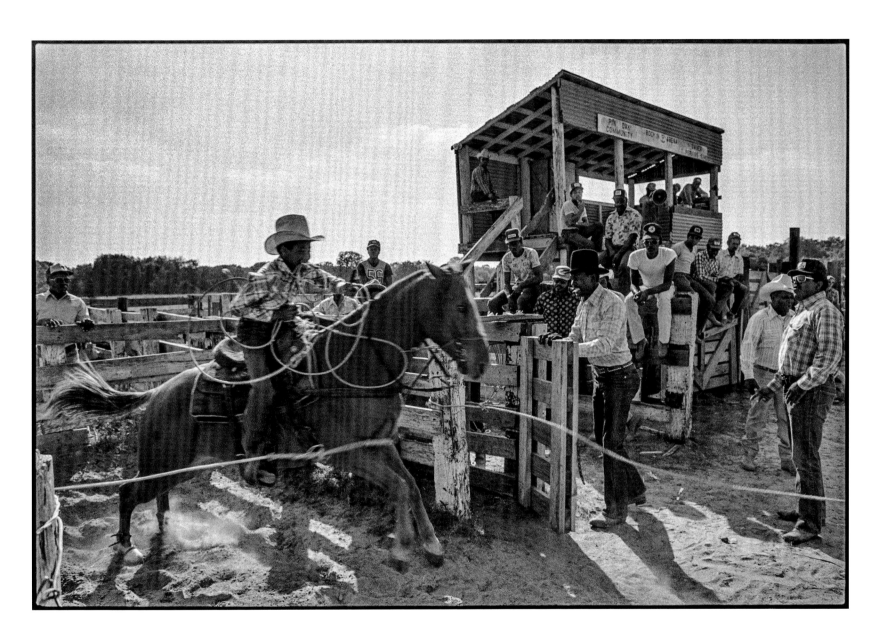

53

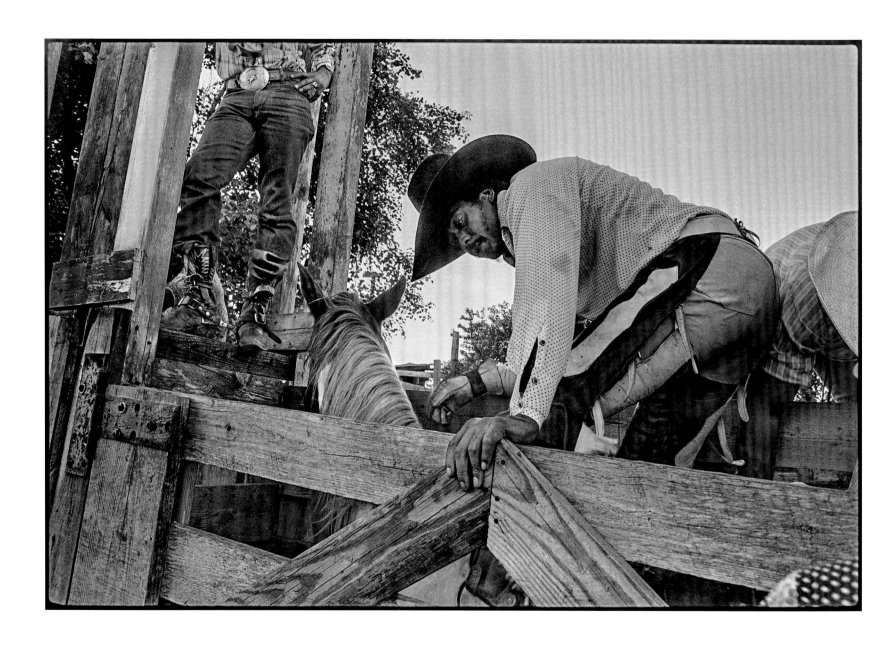

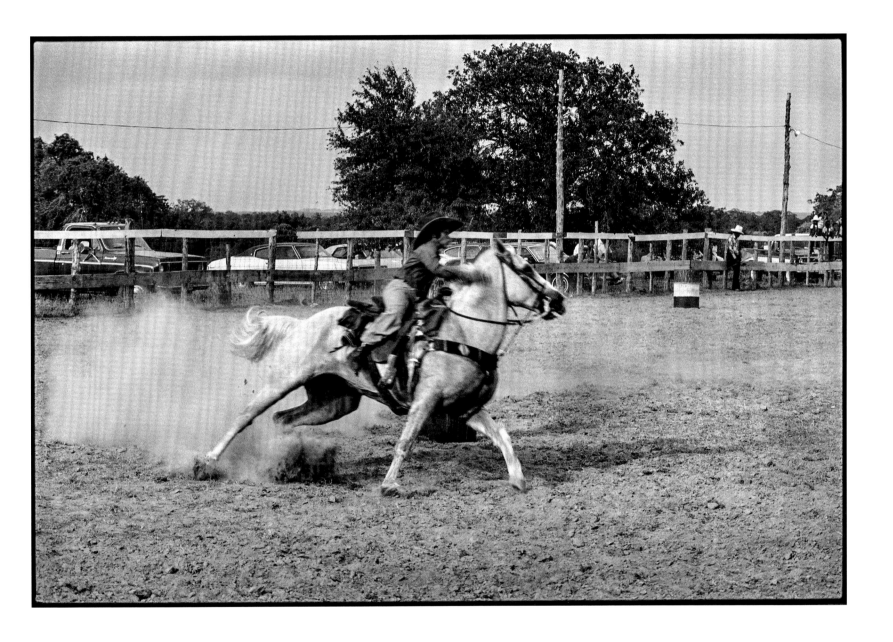

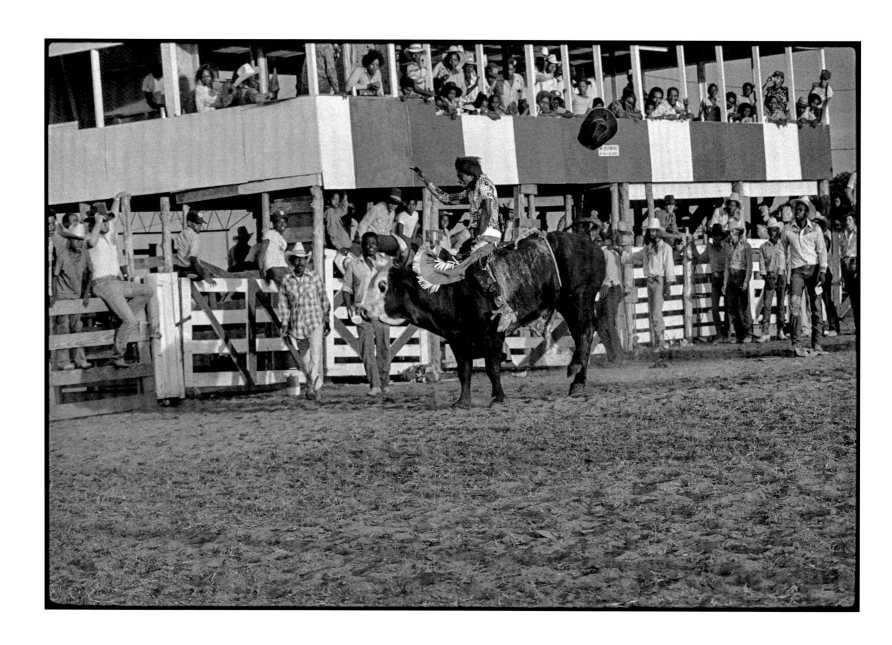

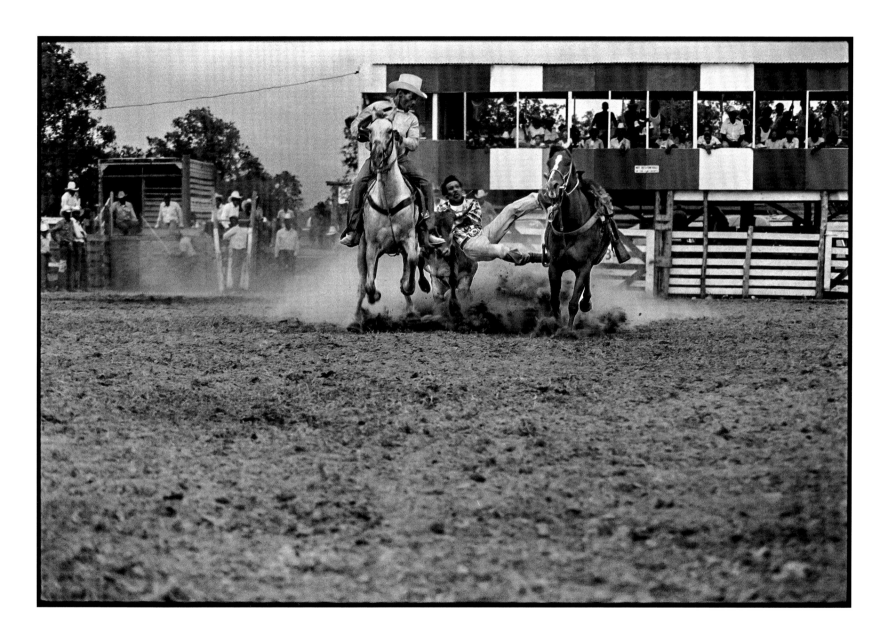

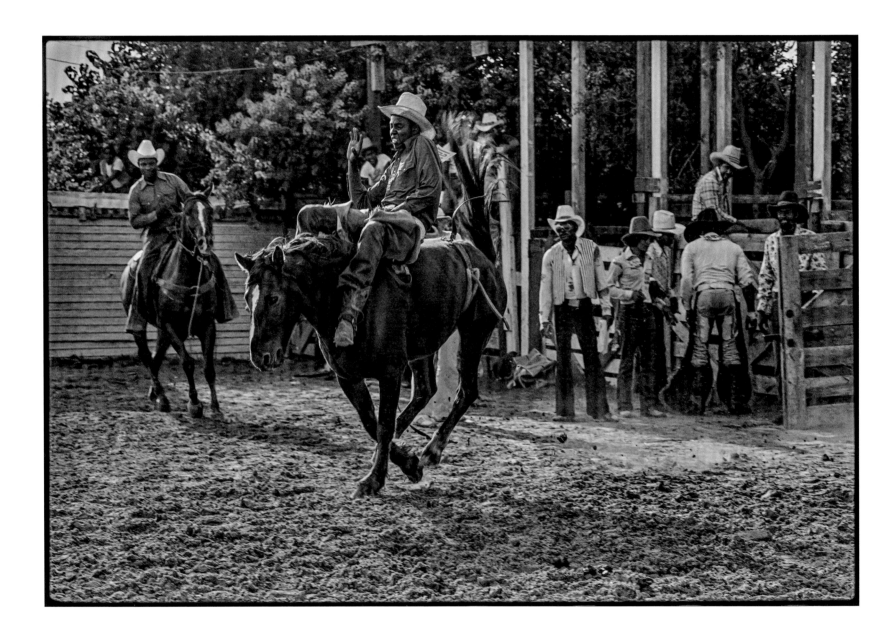

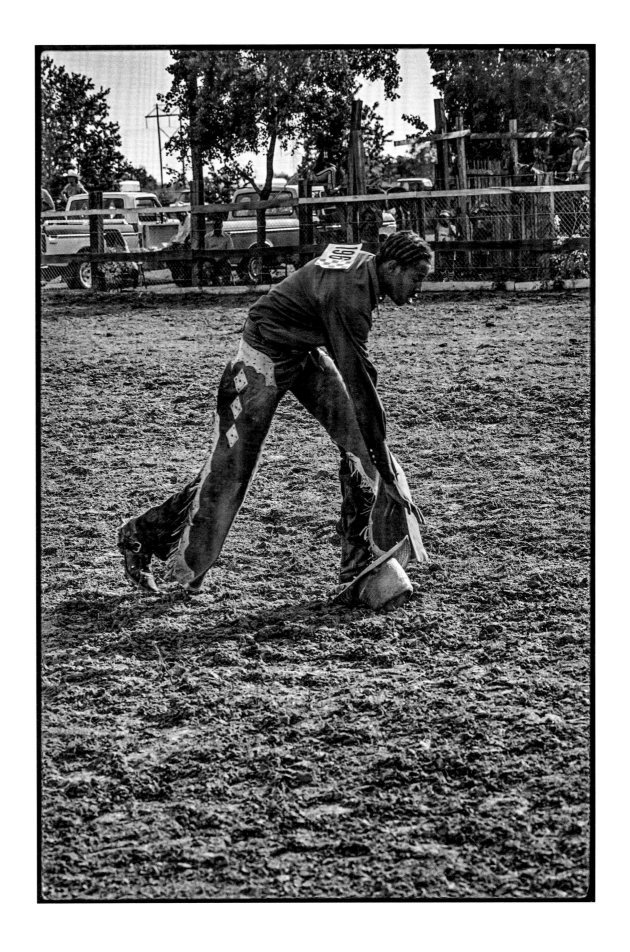

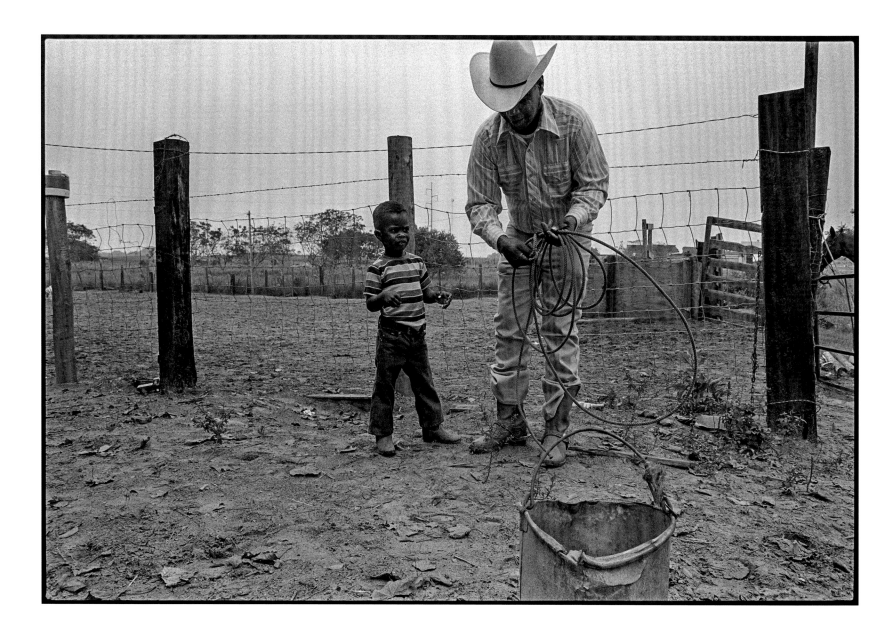

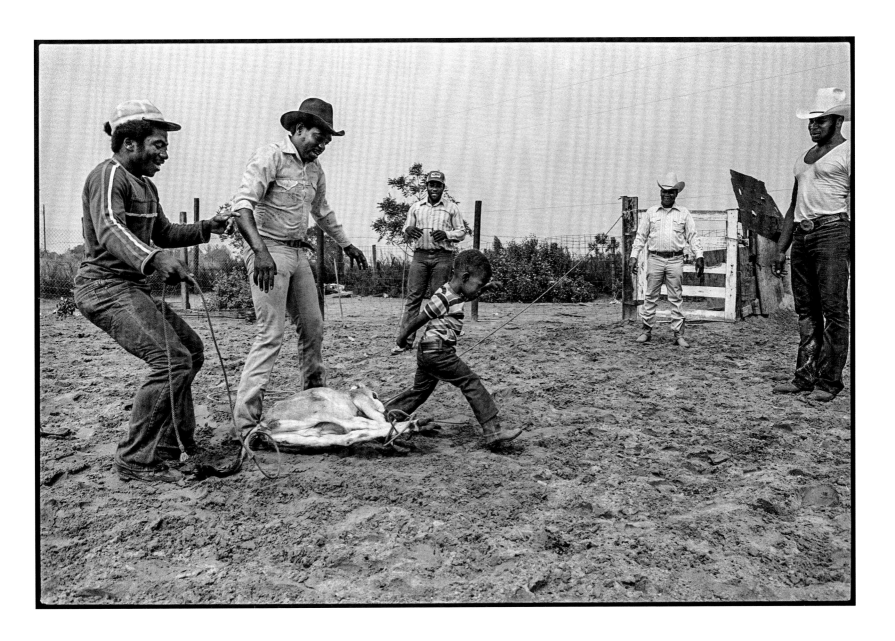

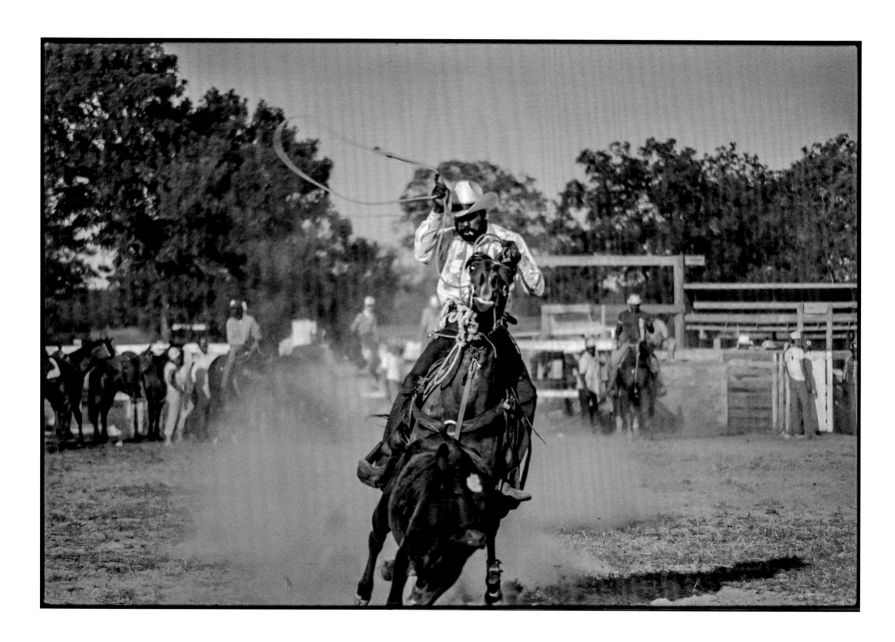

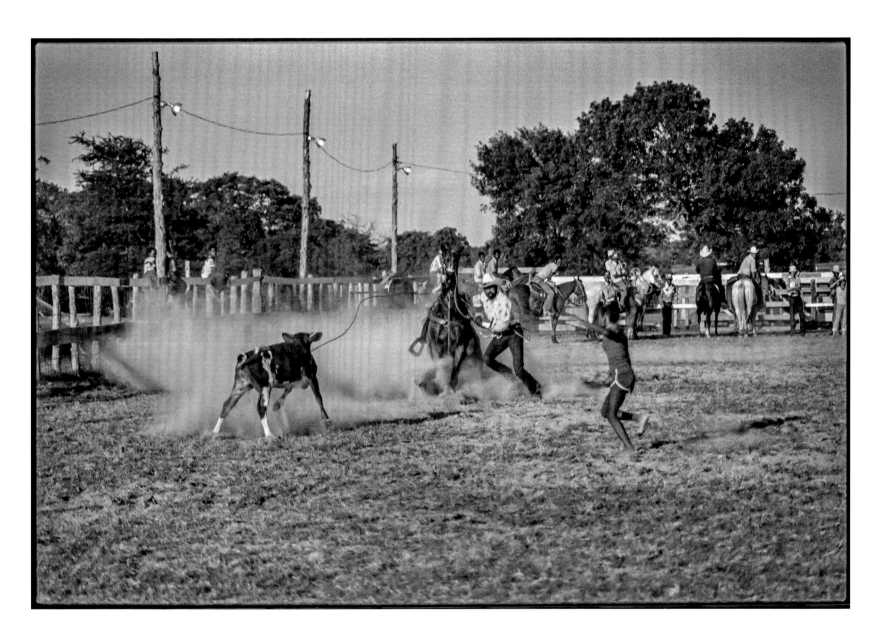

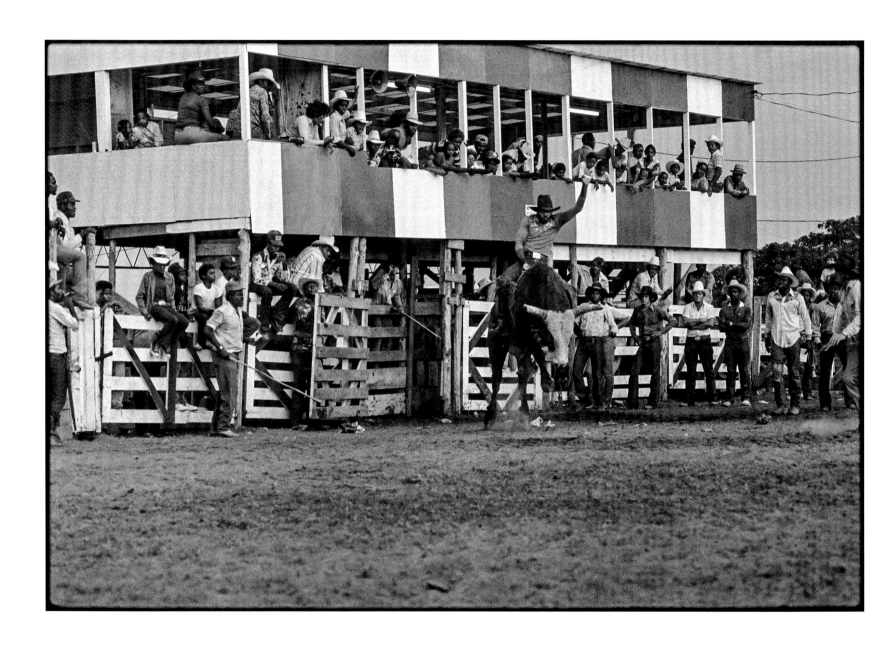

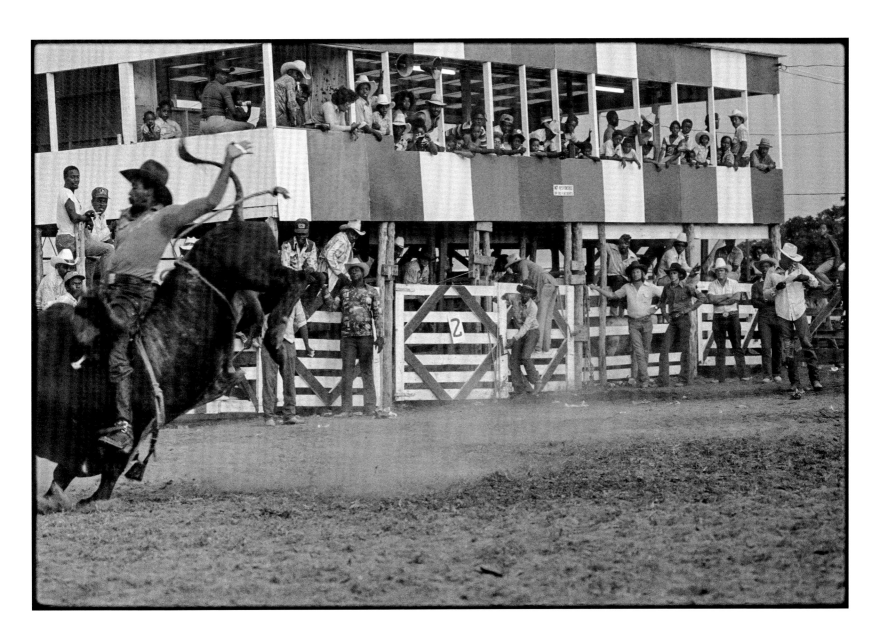

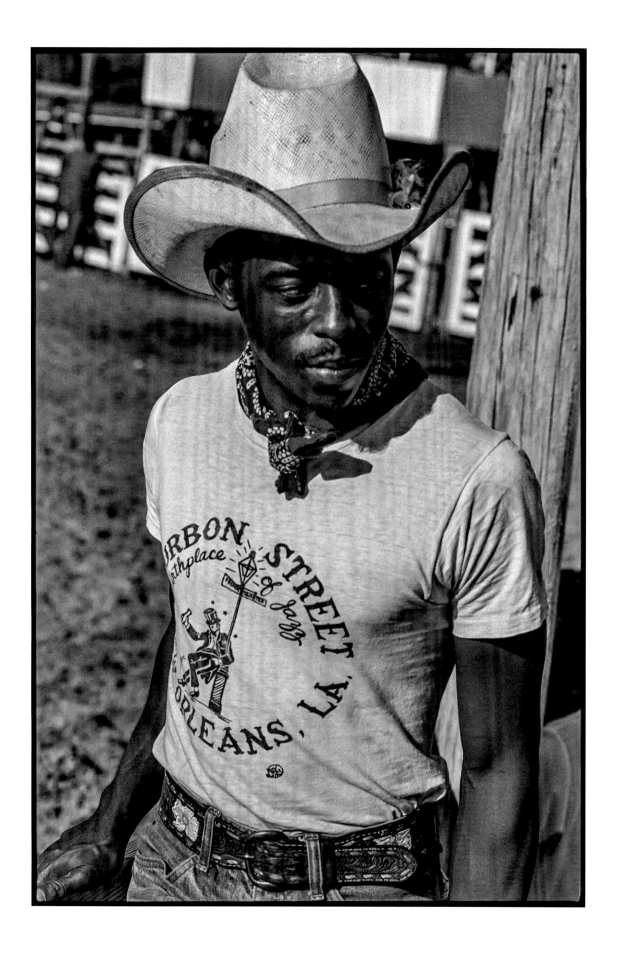

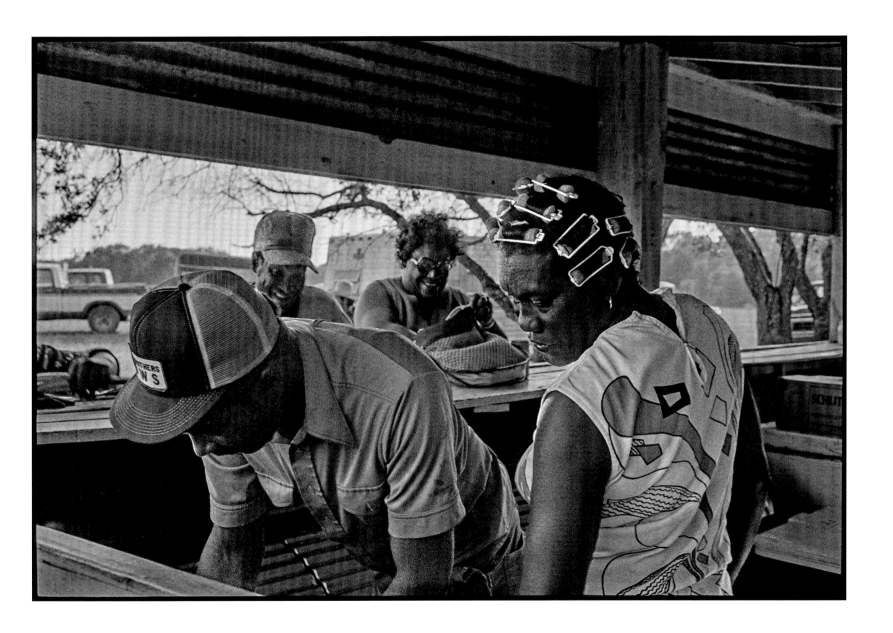

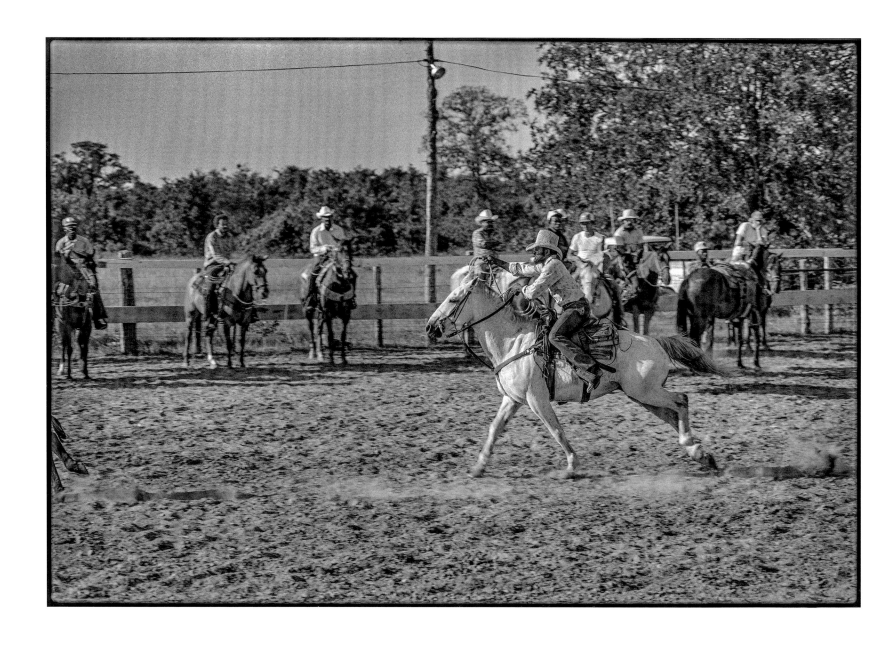

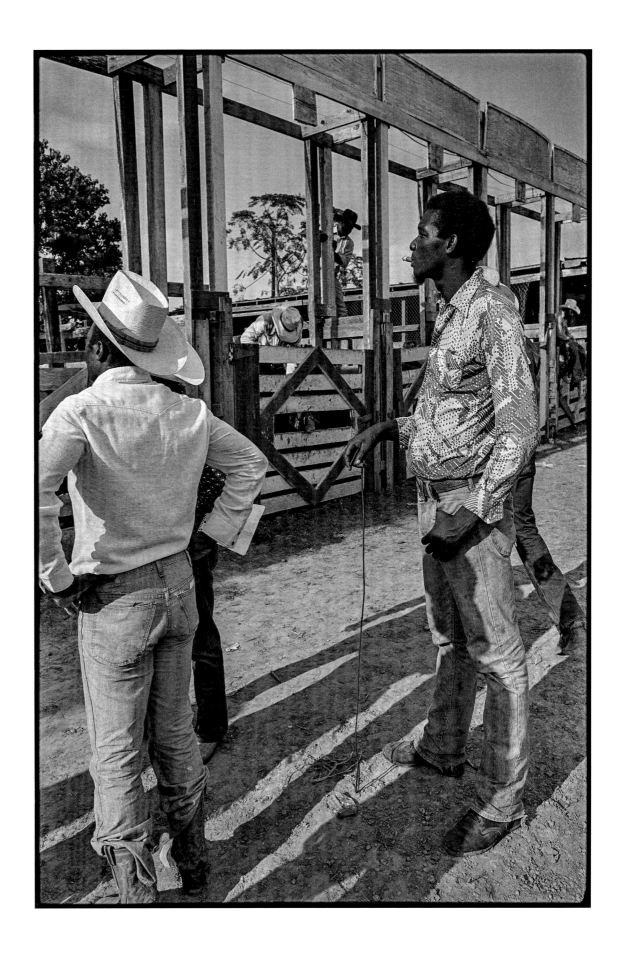

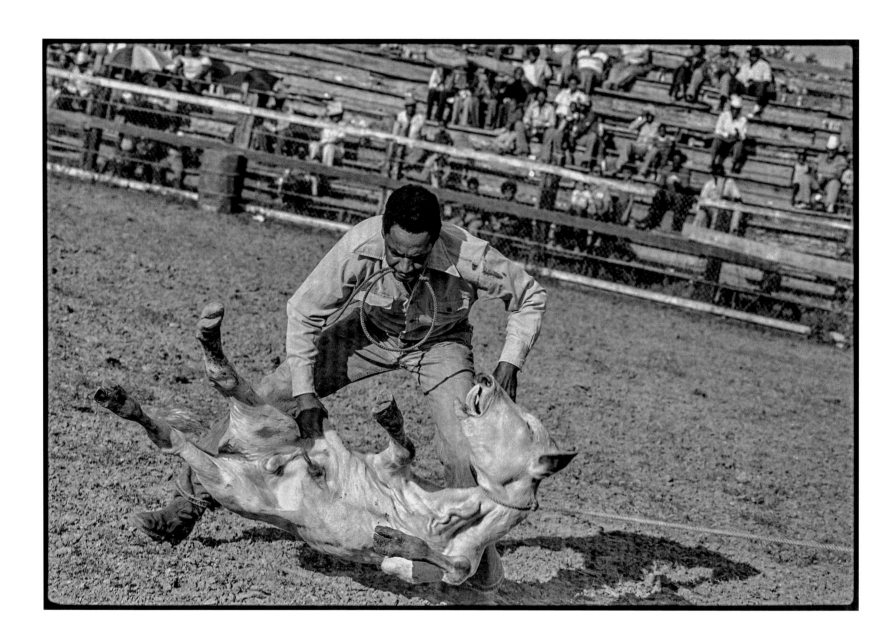

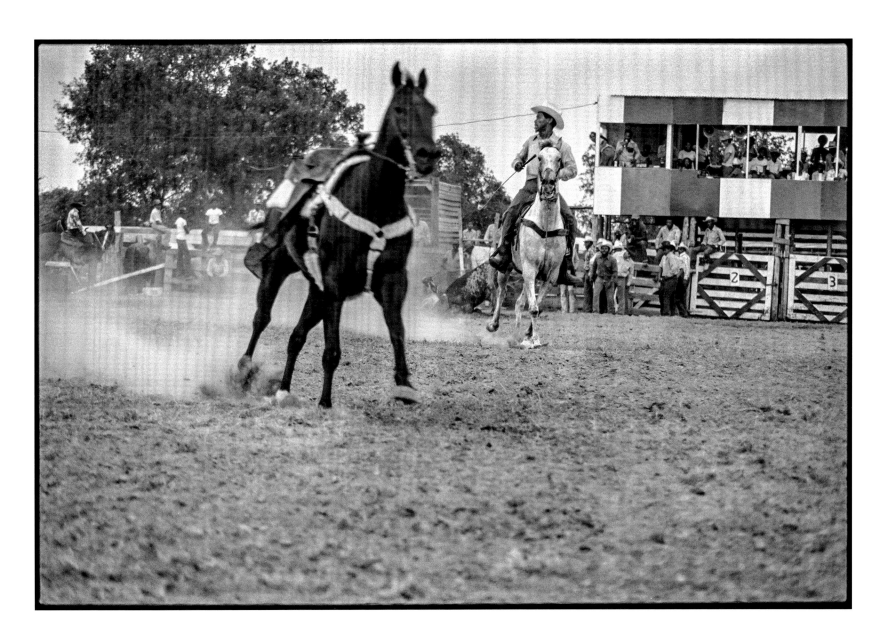

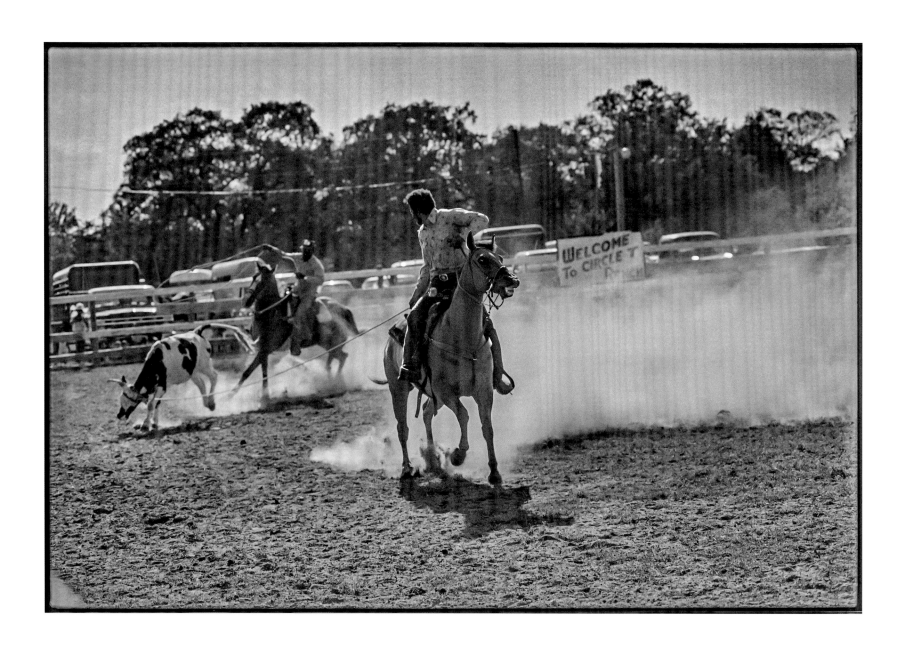

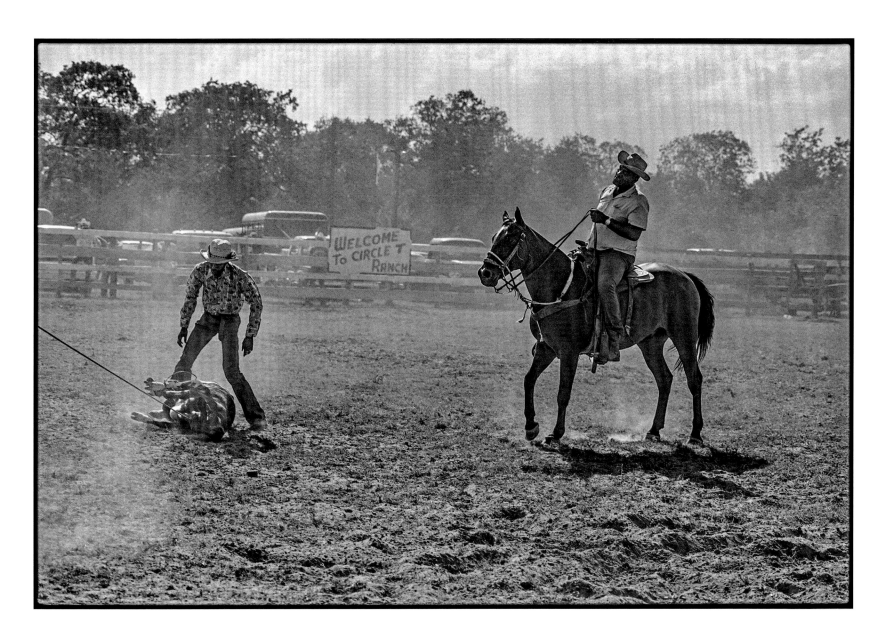

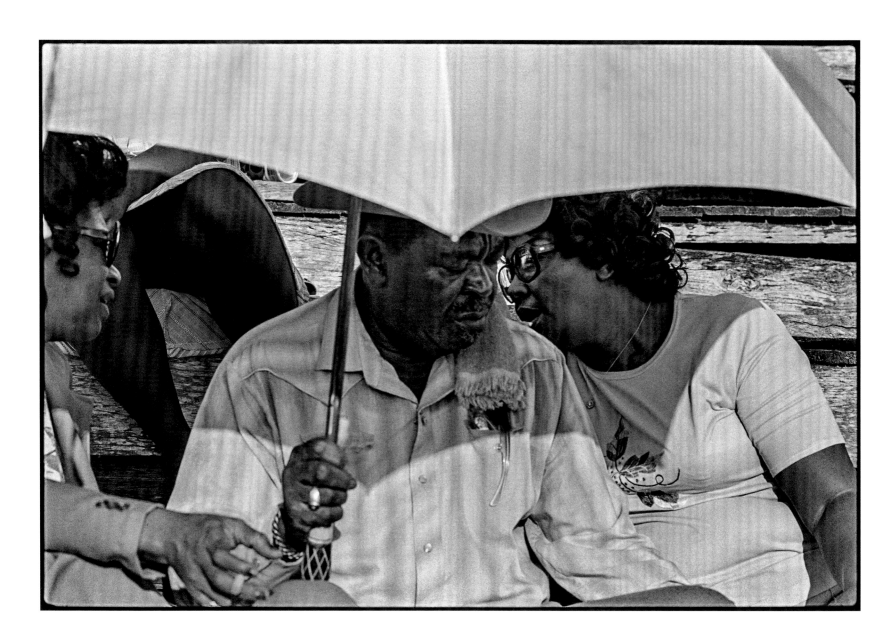

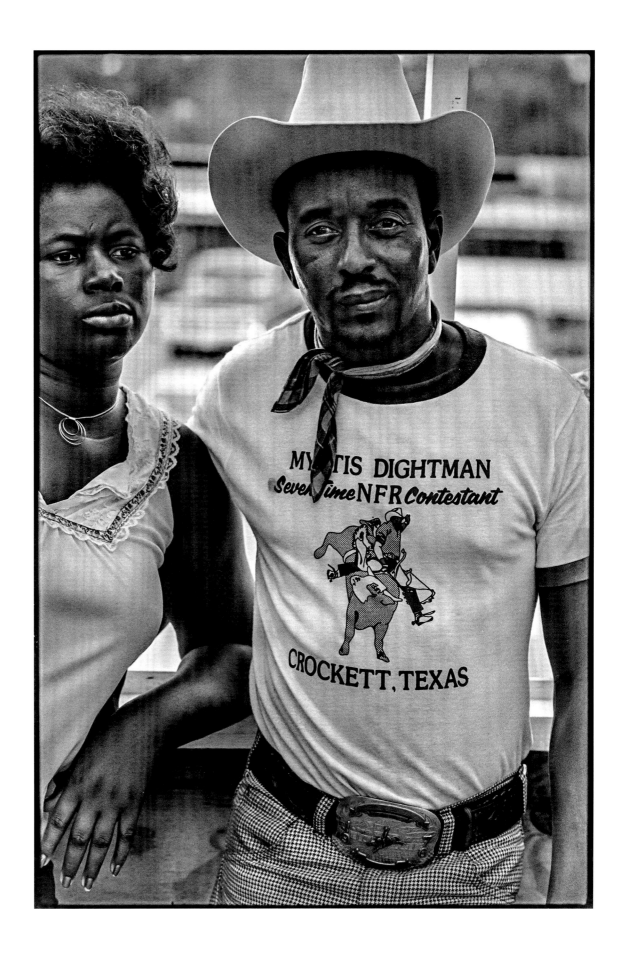

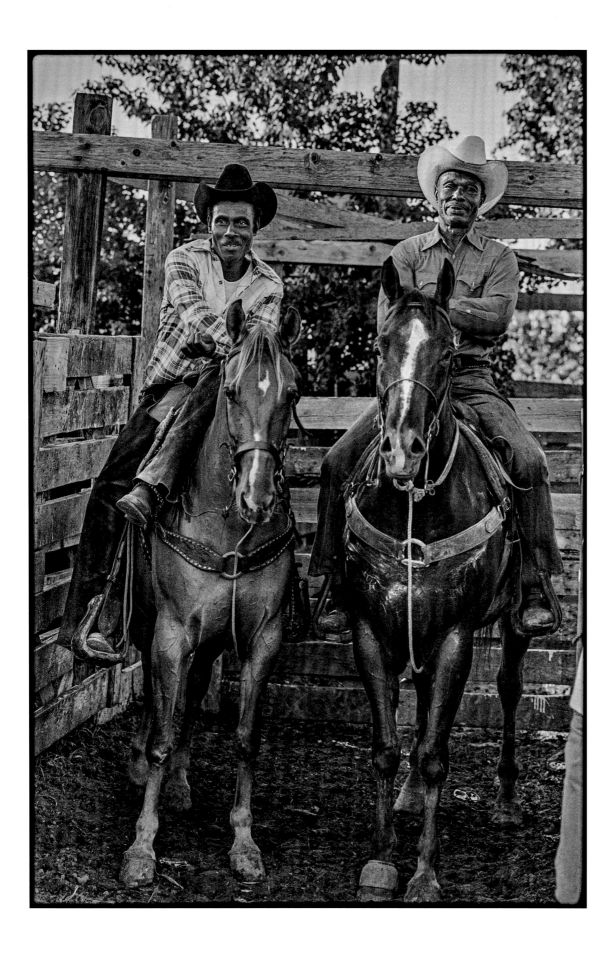

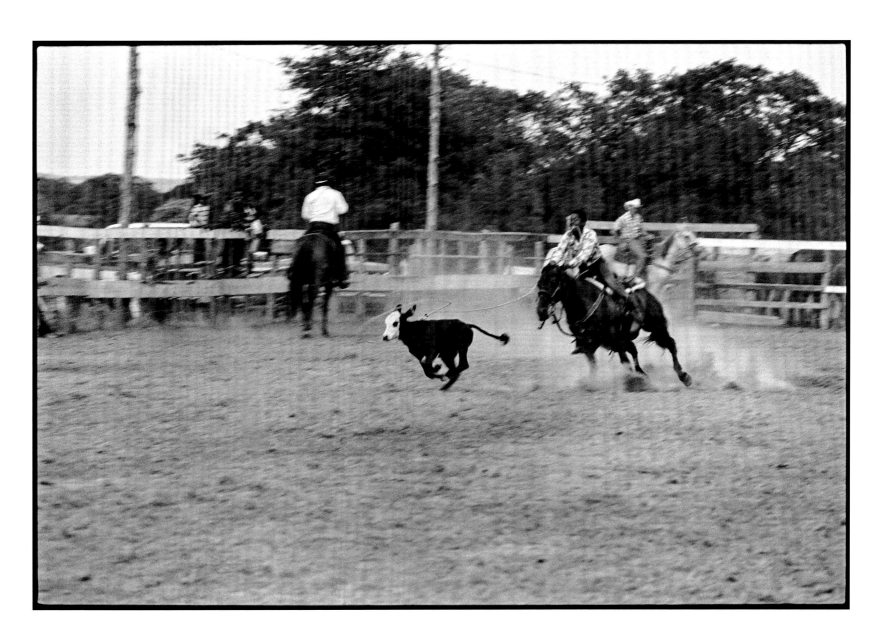

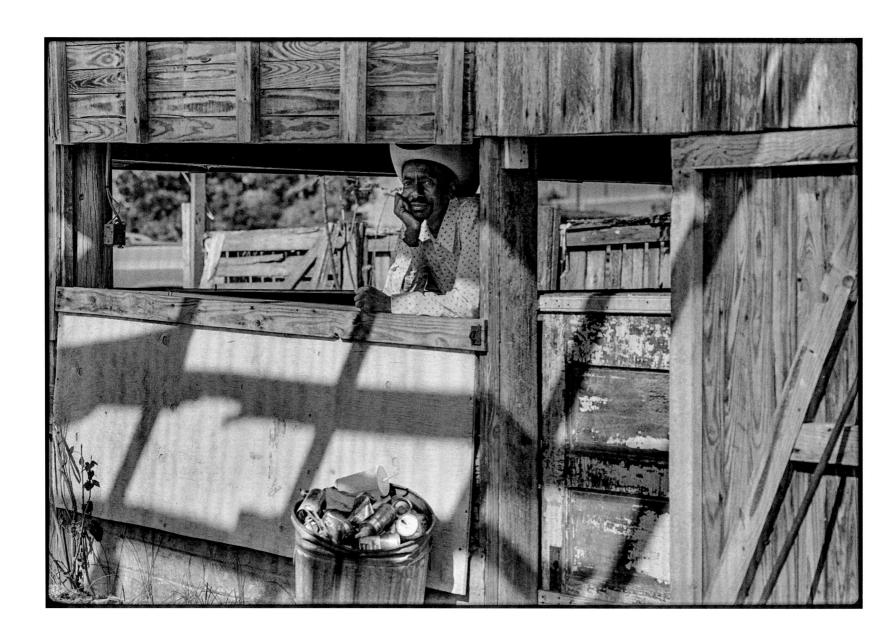

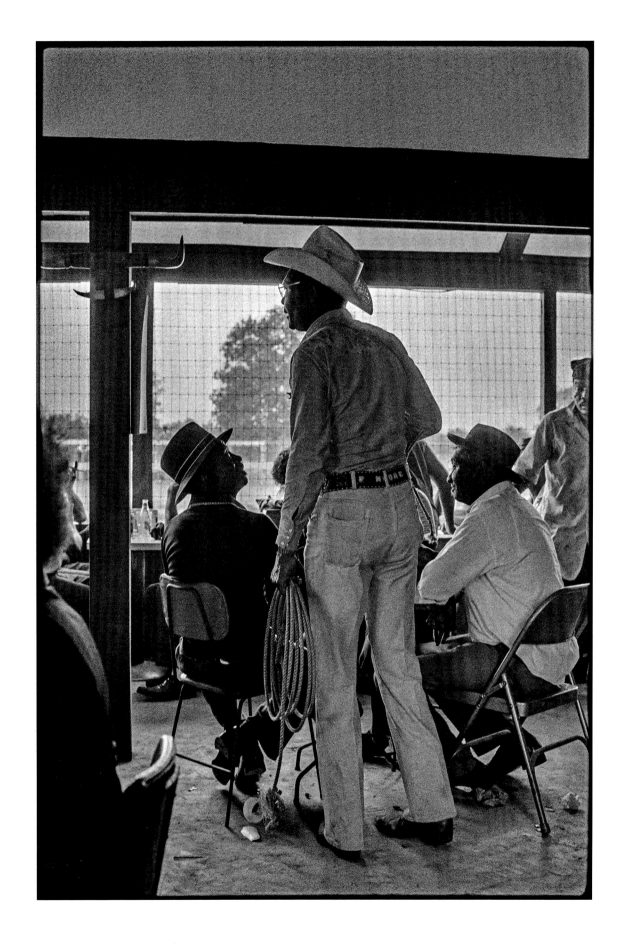

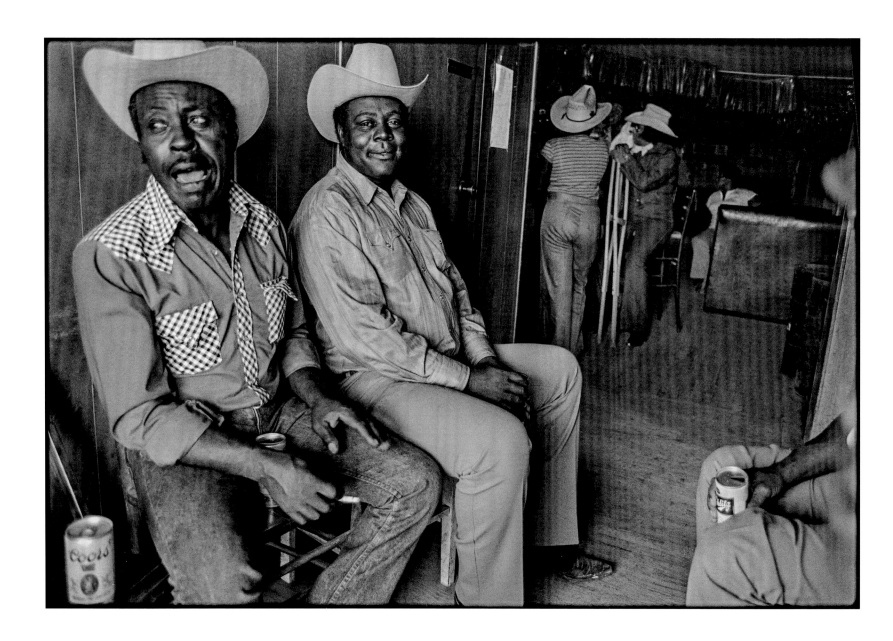

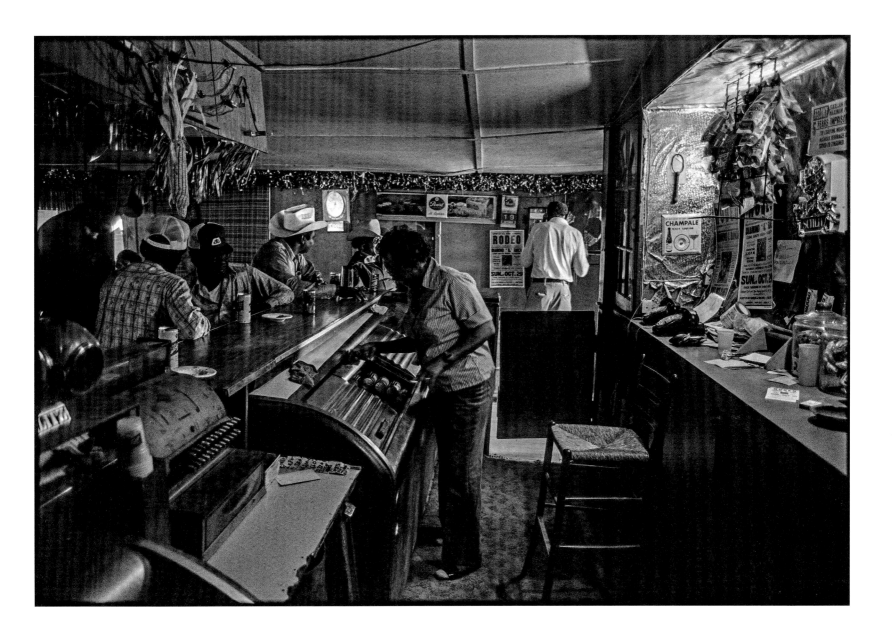

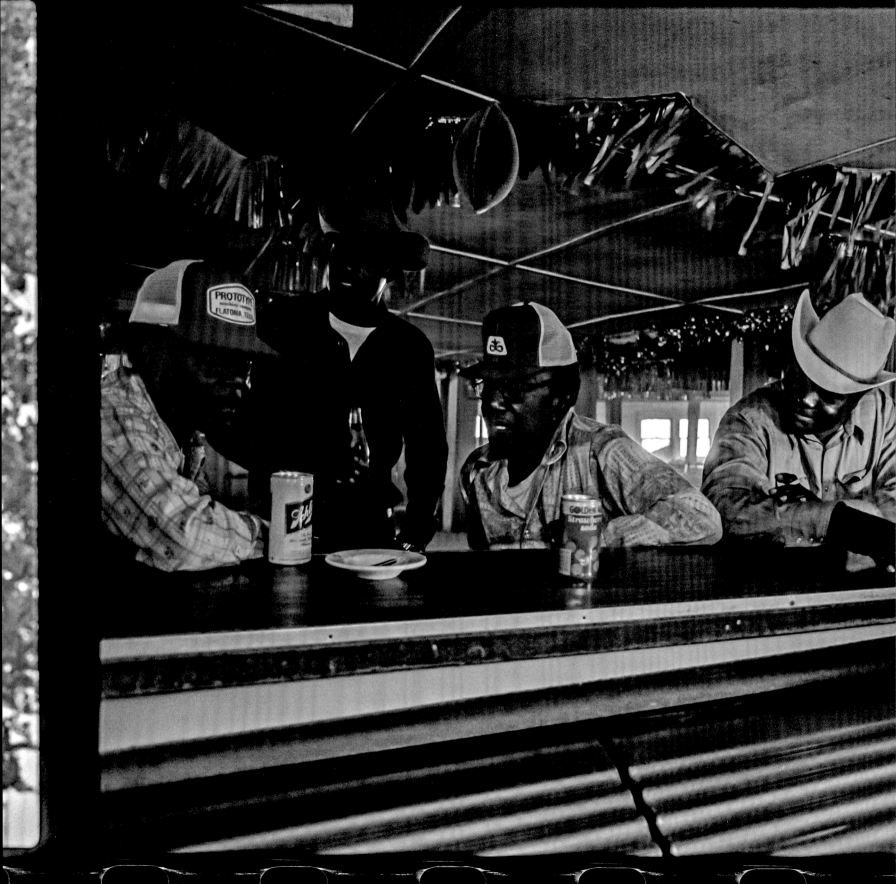

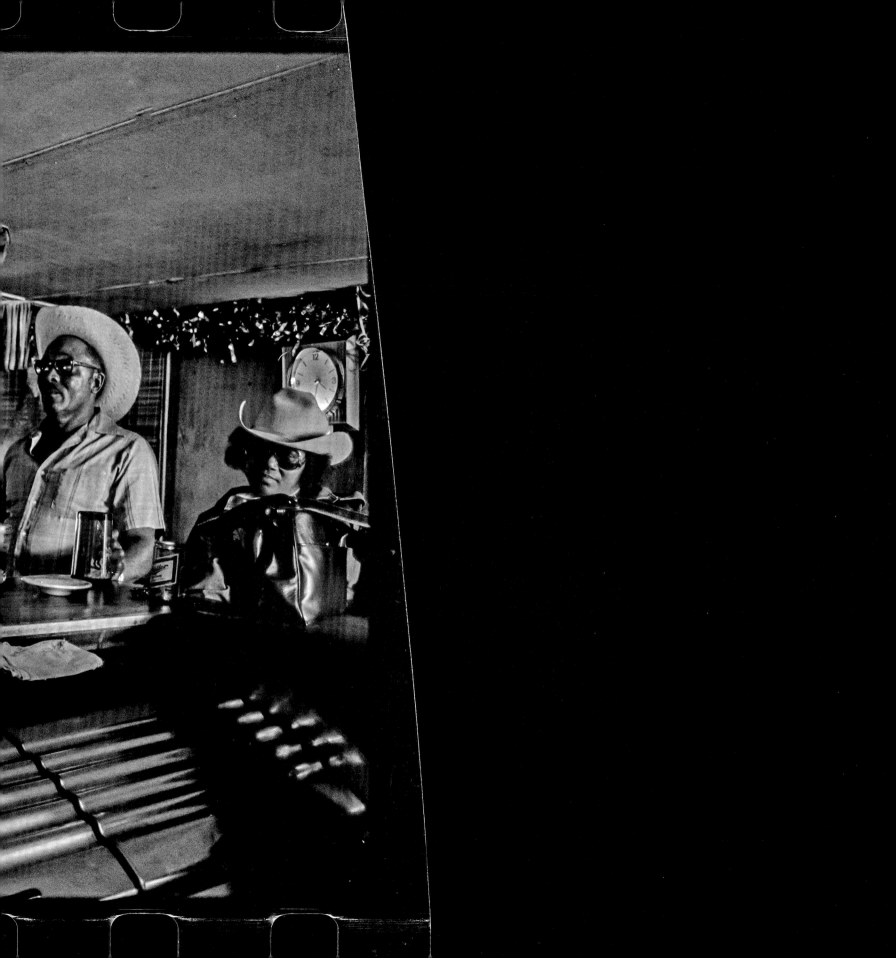

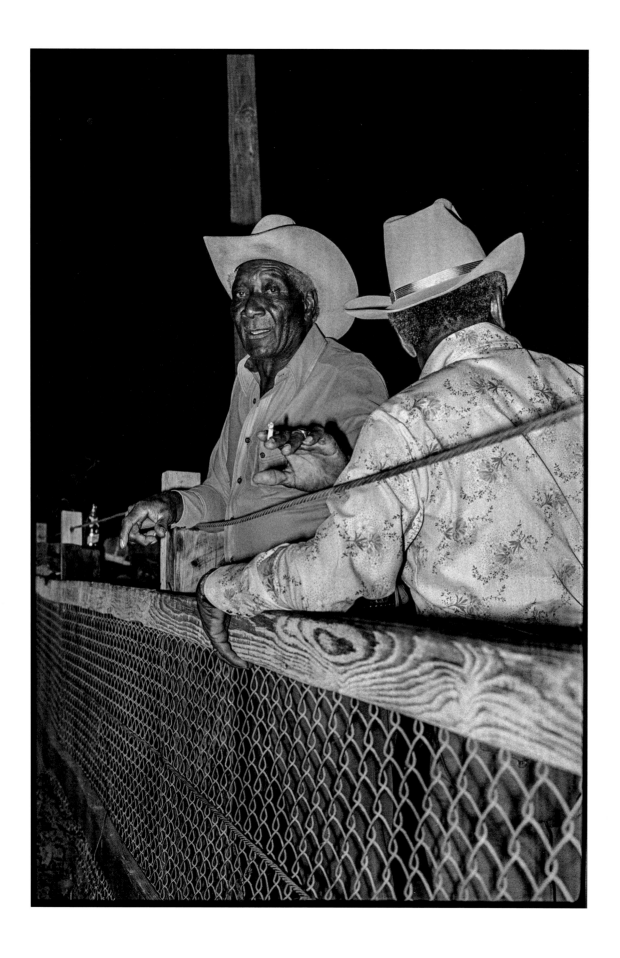

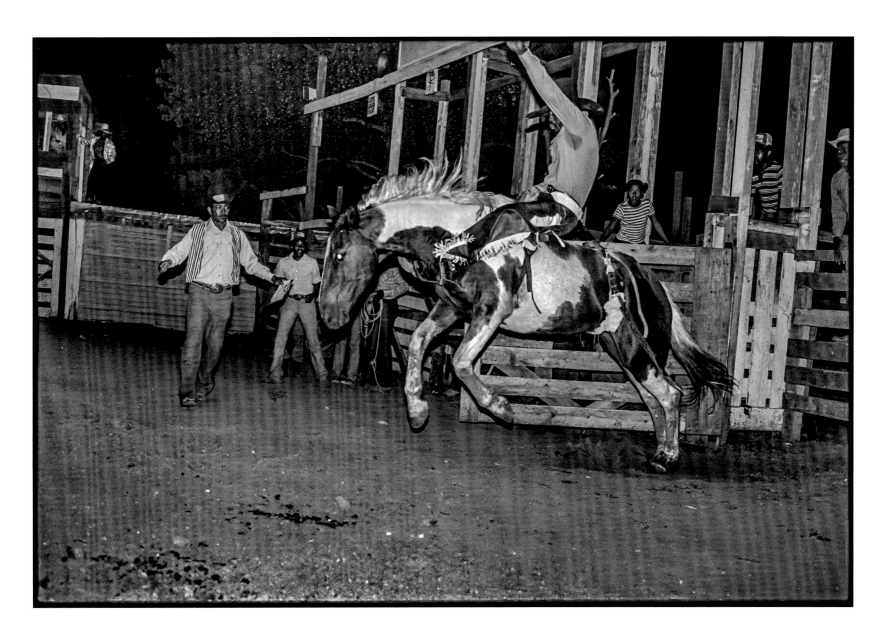

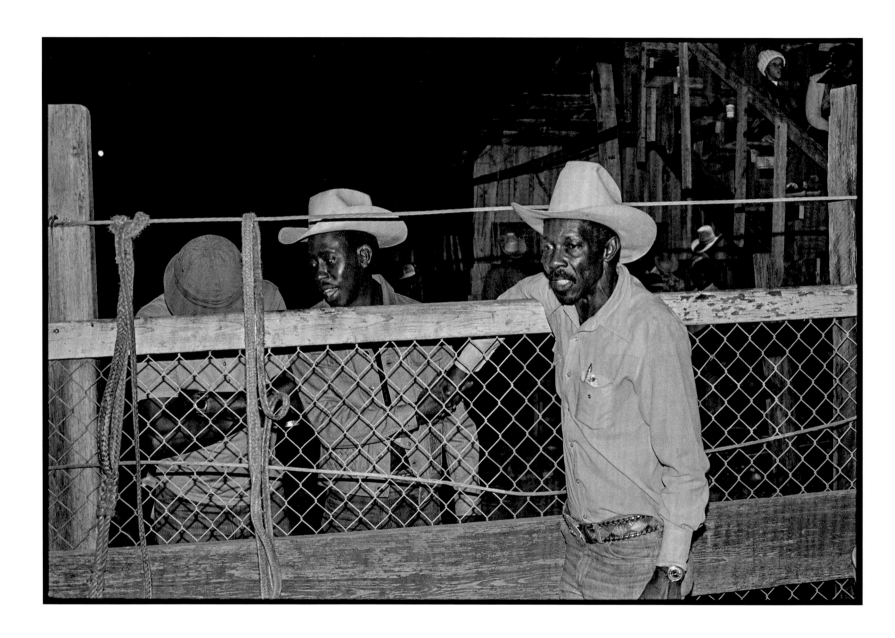

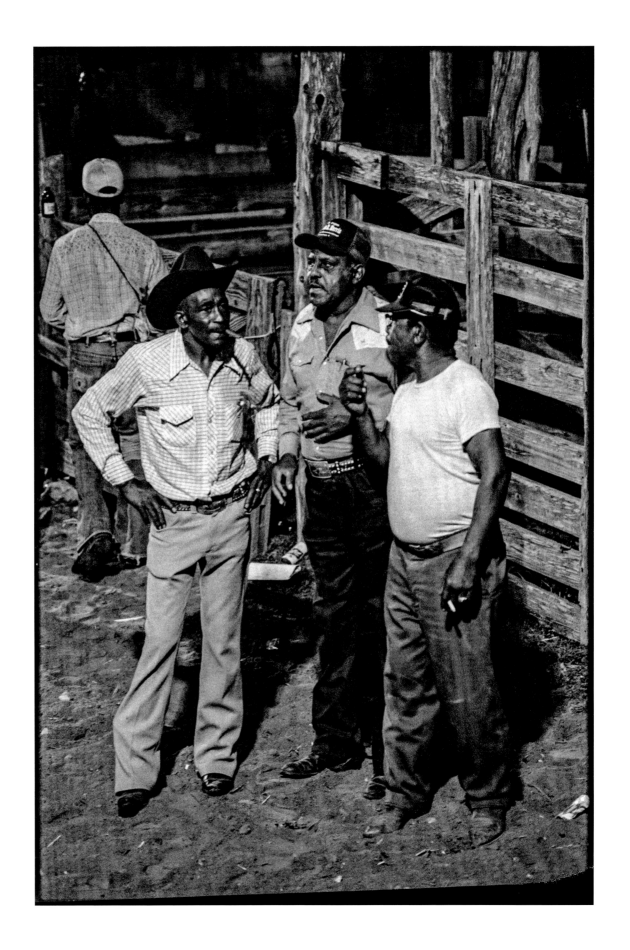

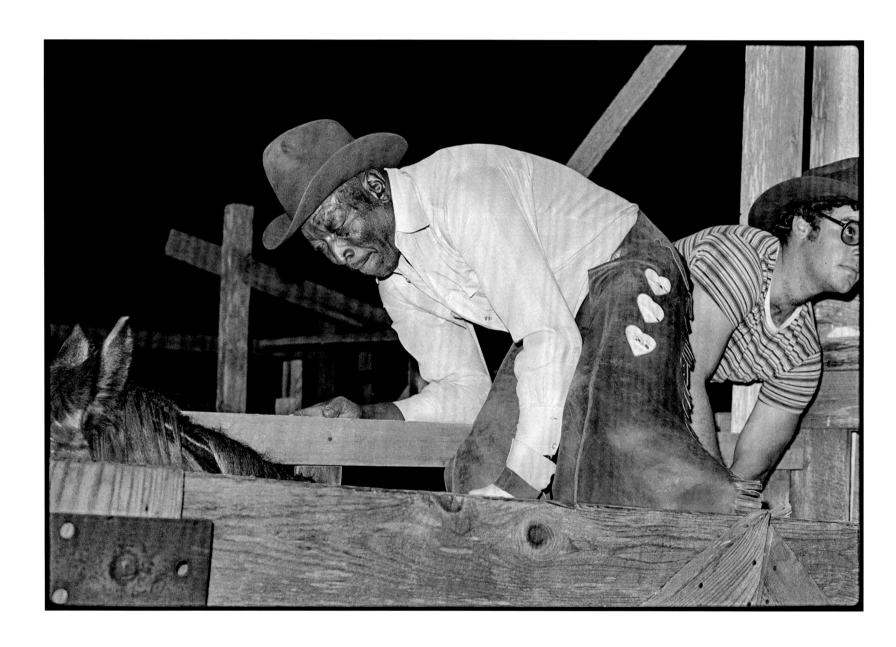

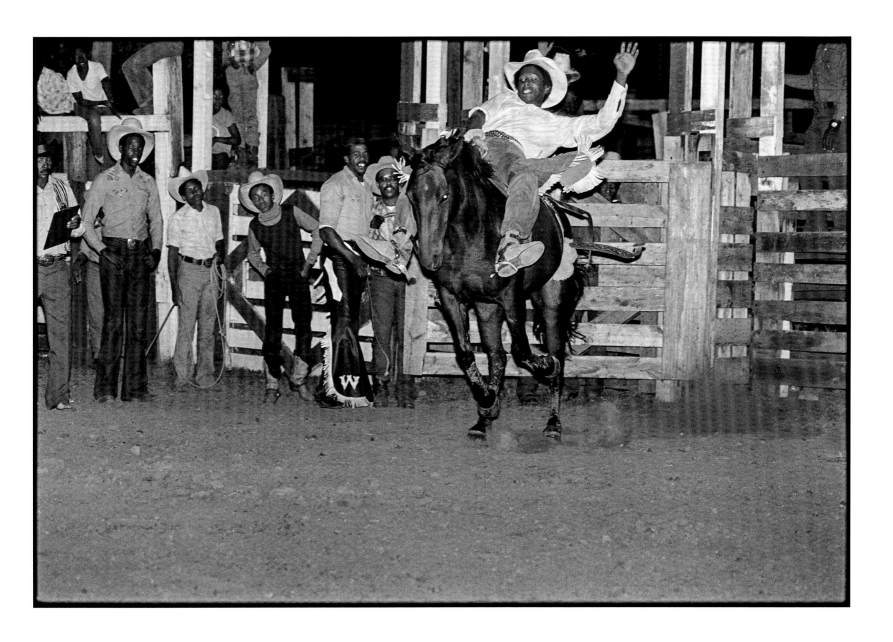

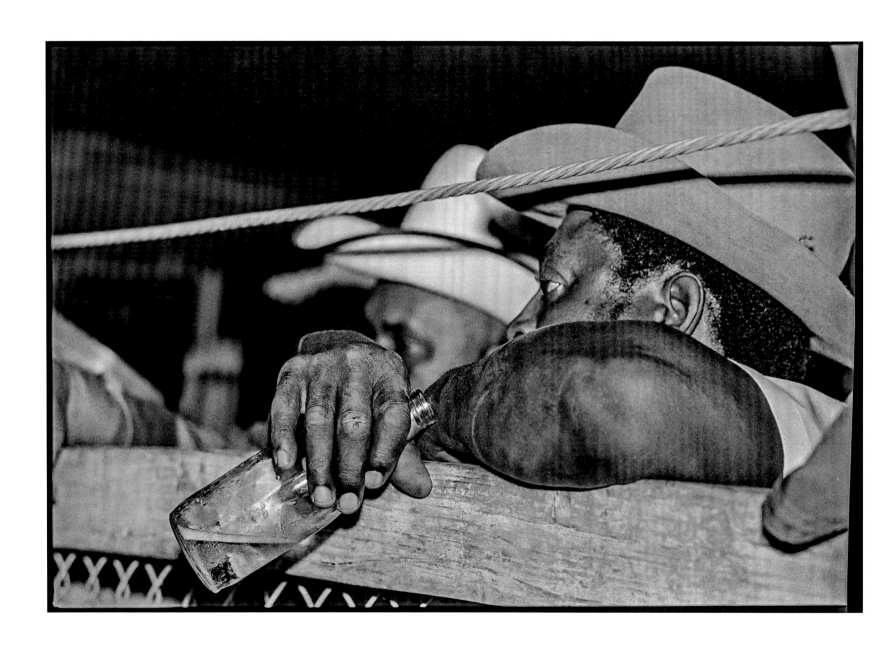

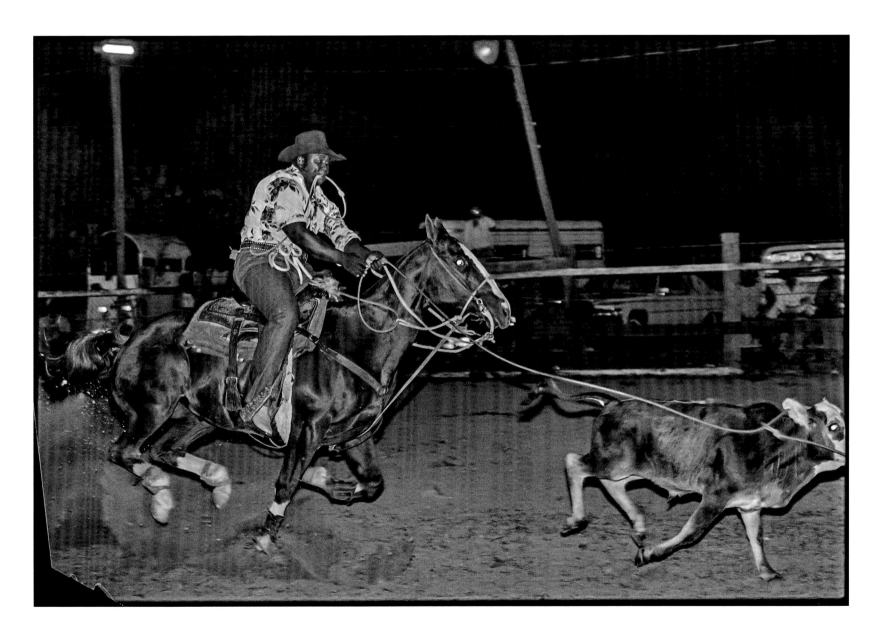

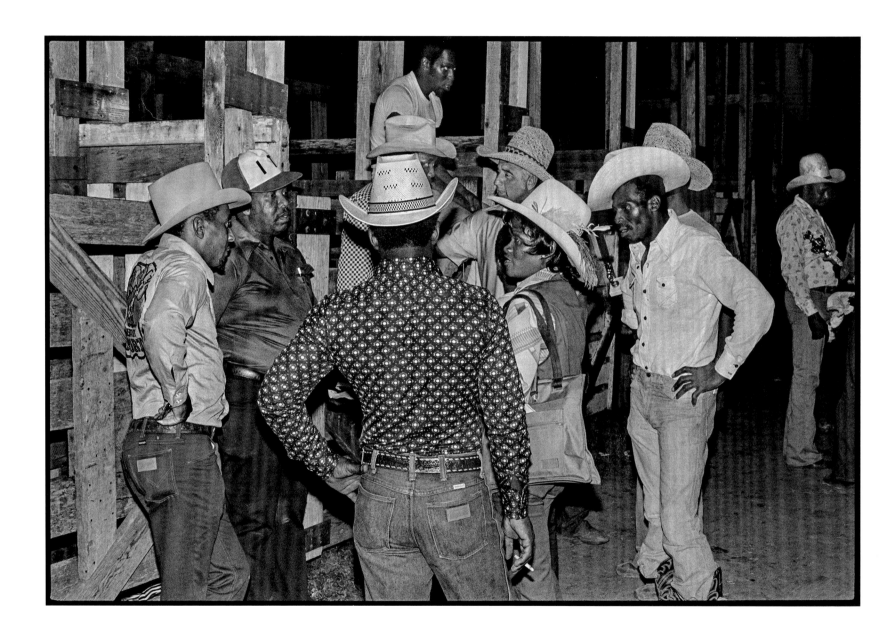

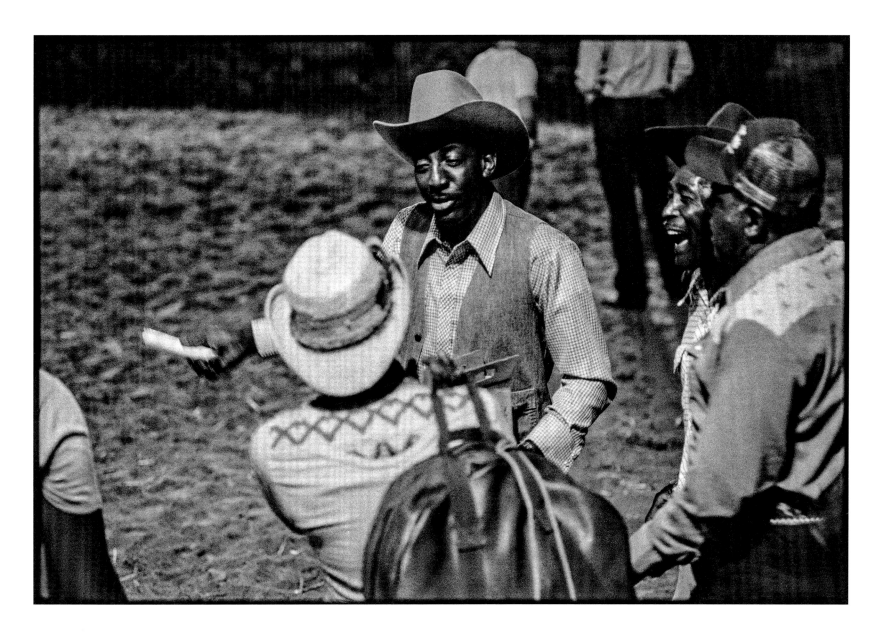

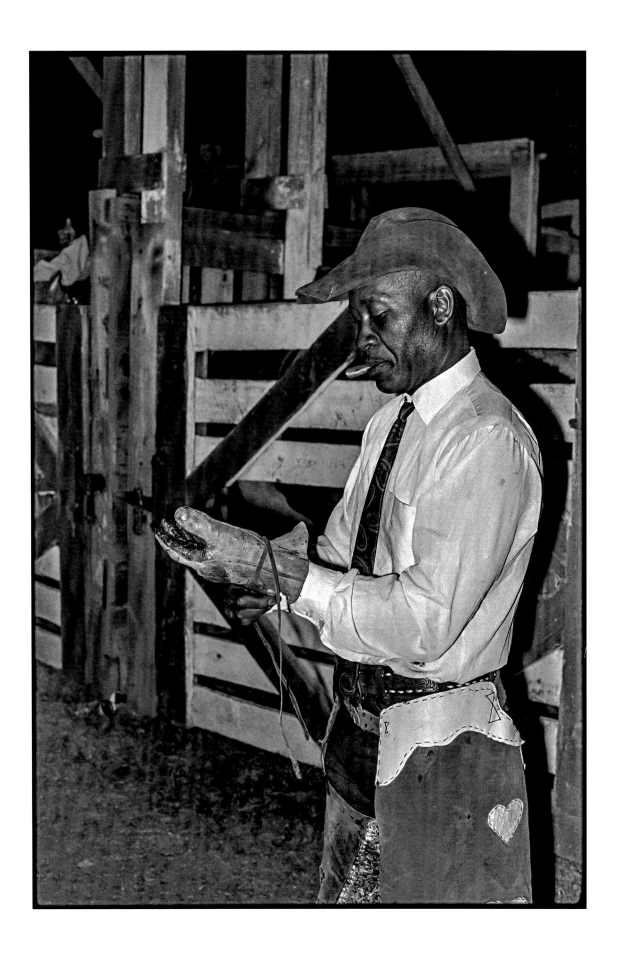

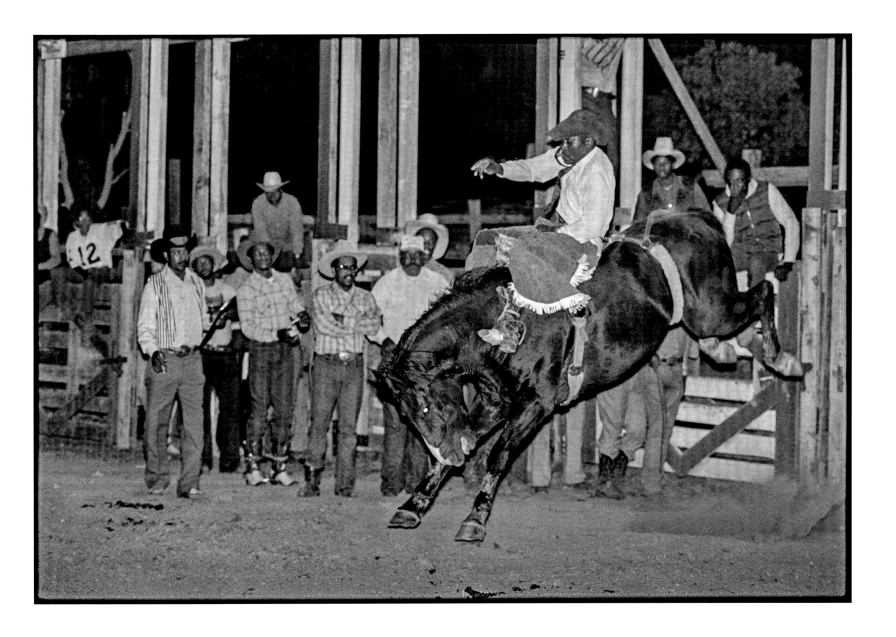

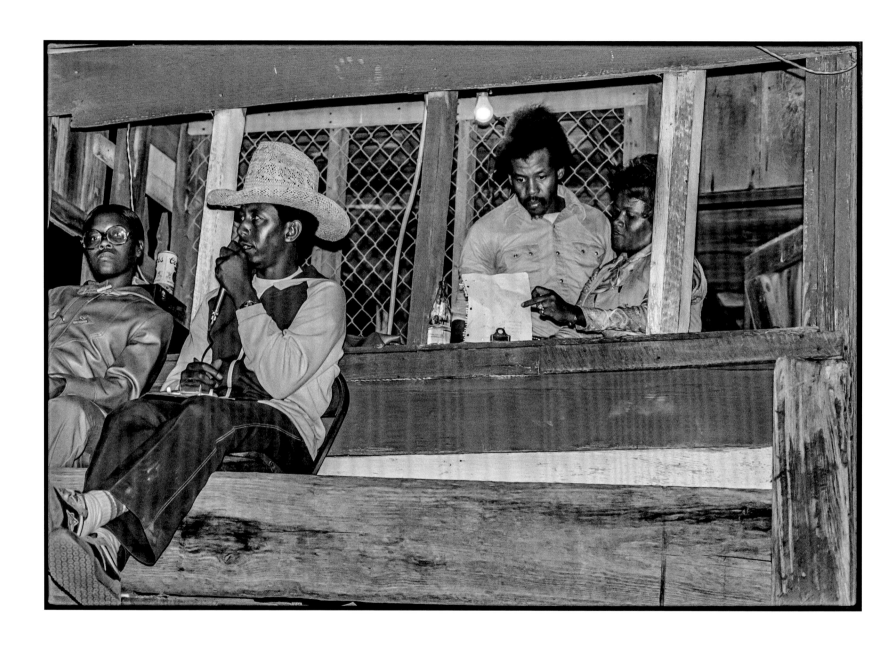

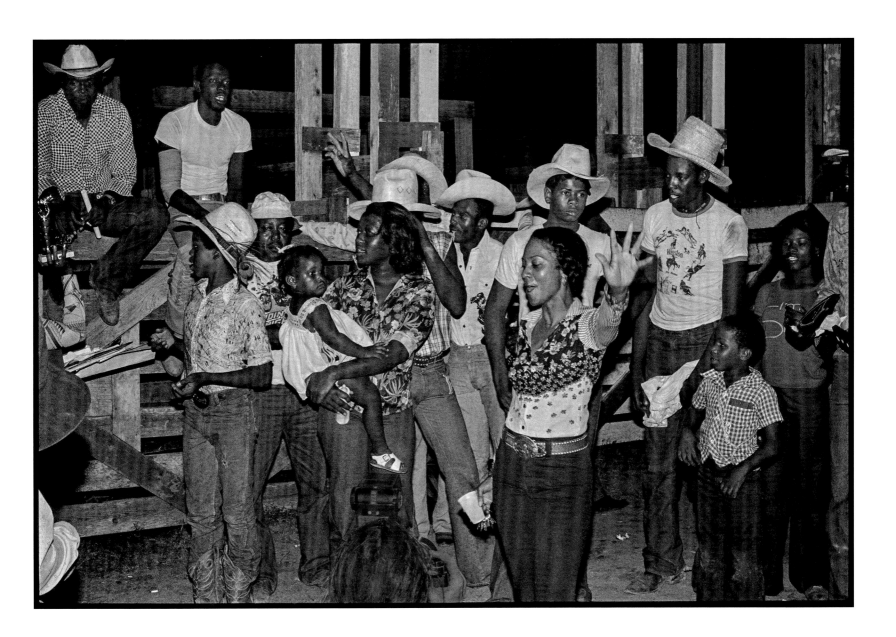

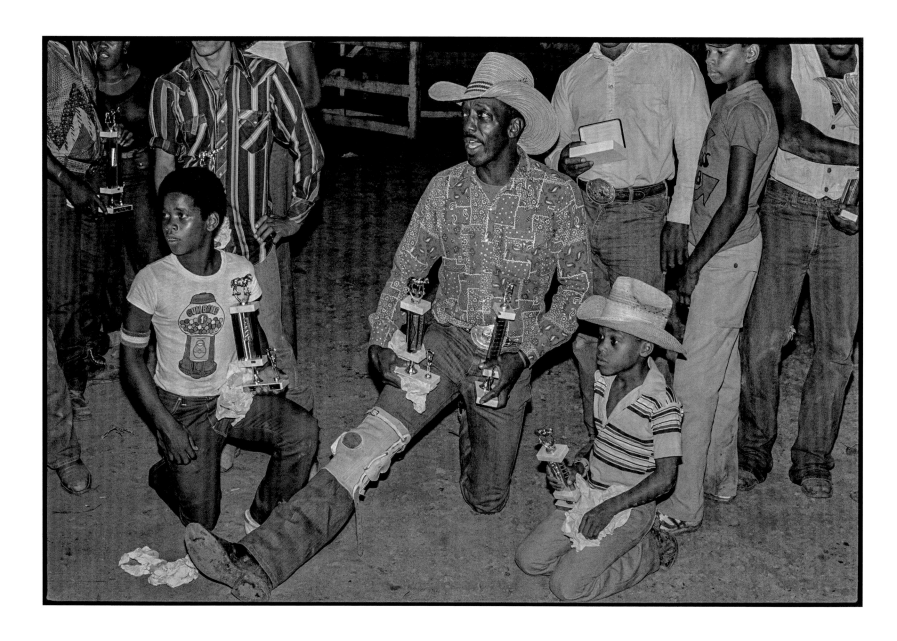

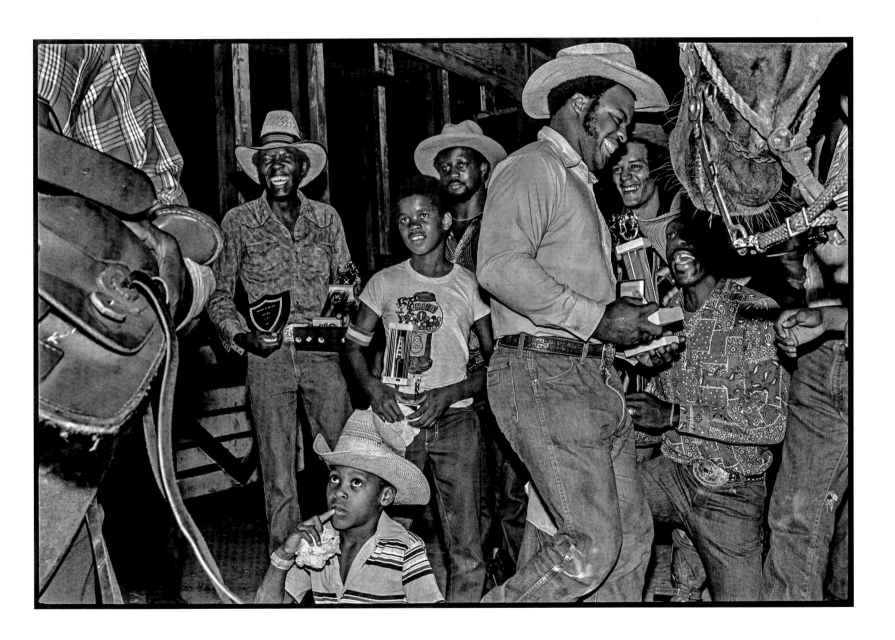

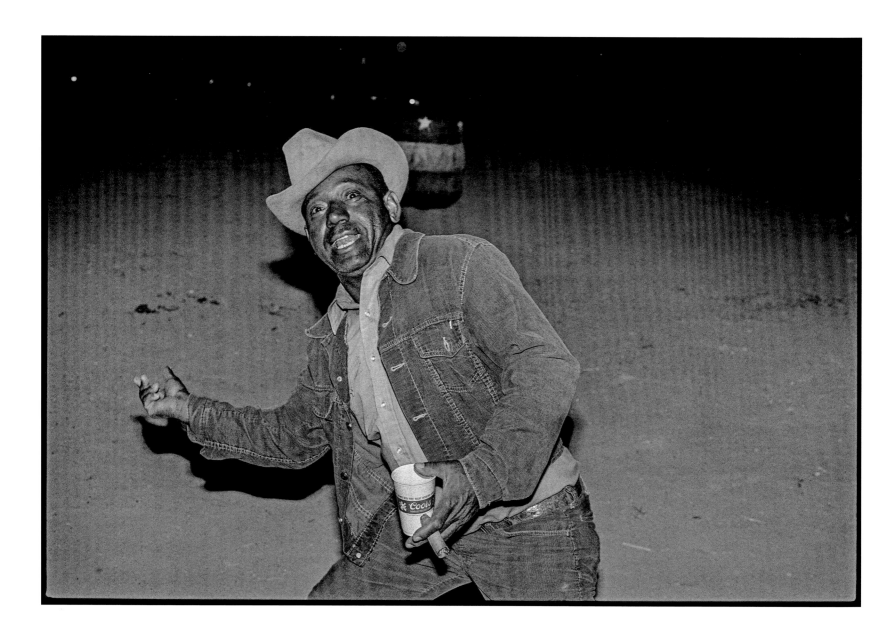

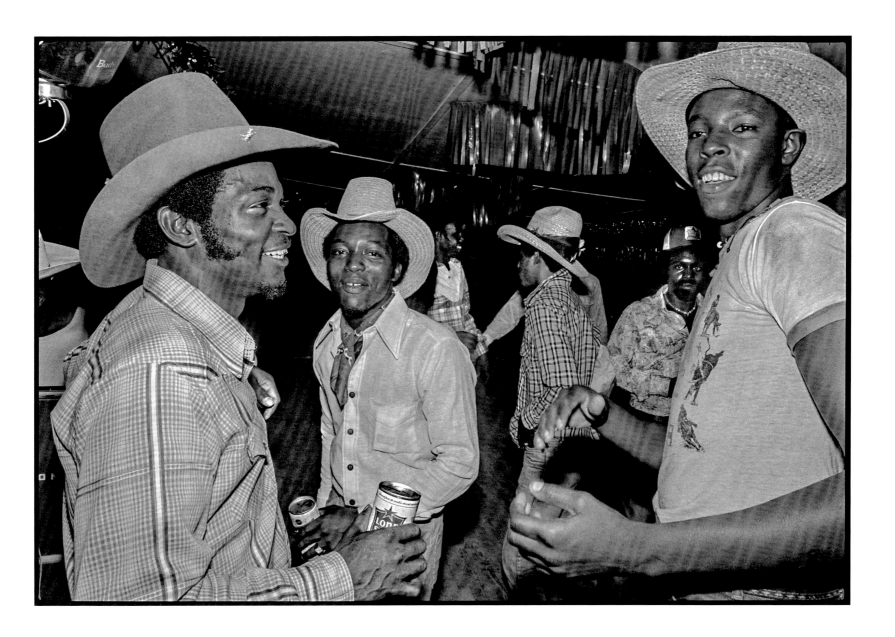

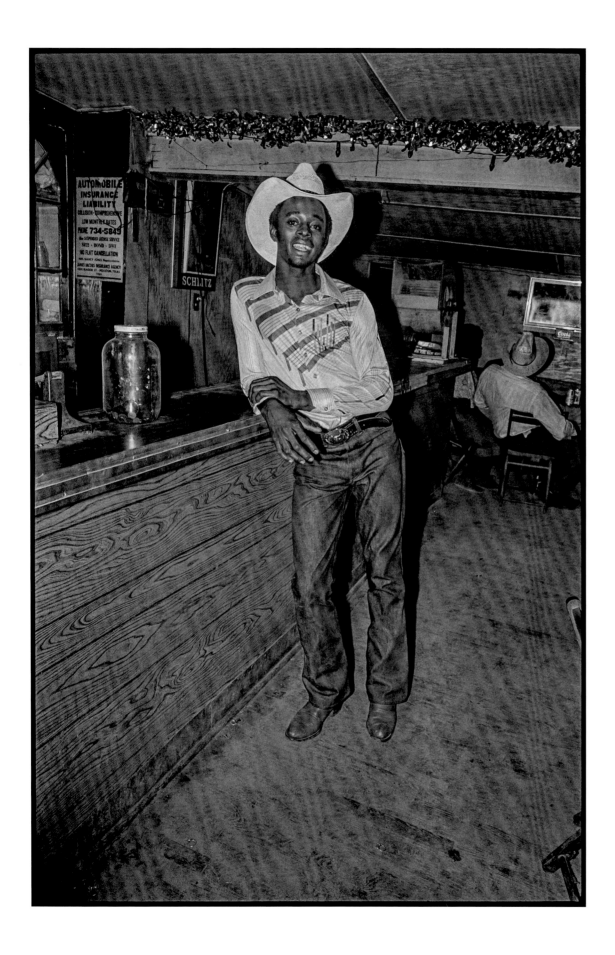

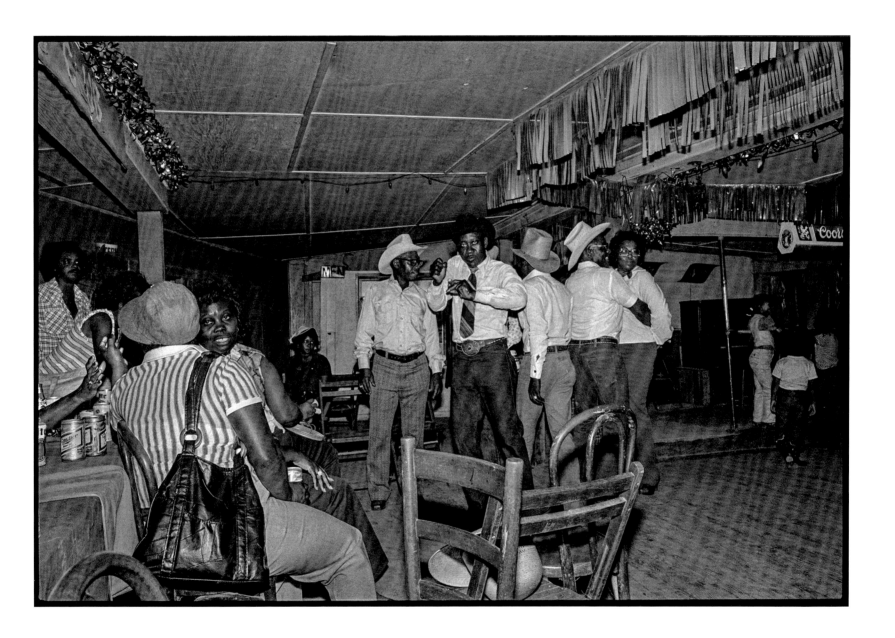

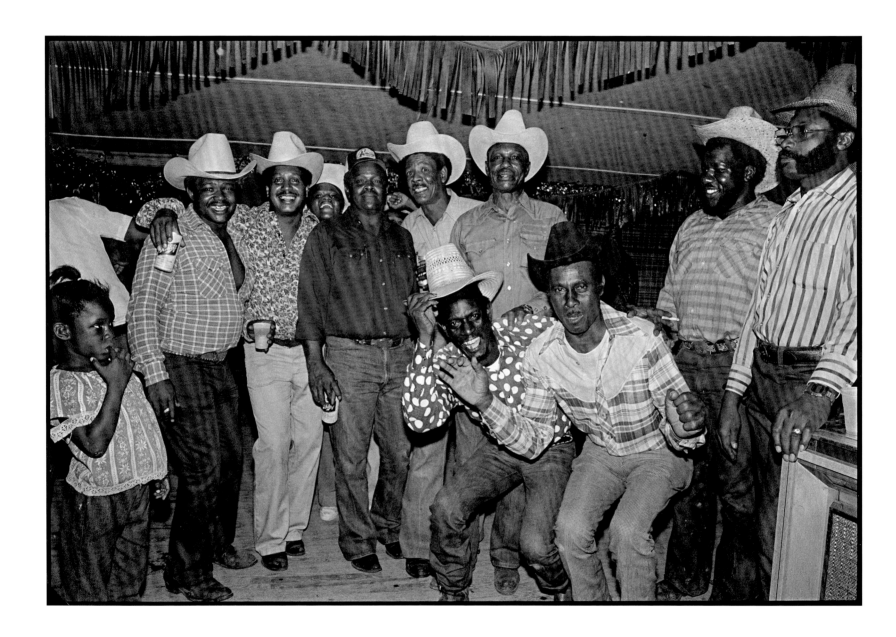

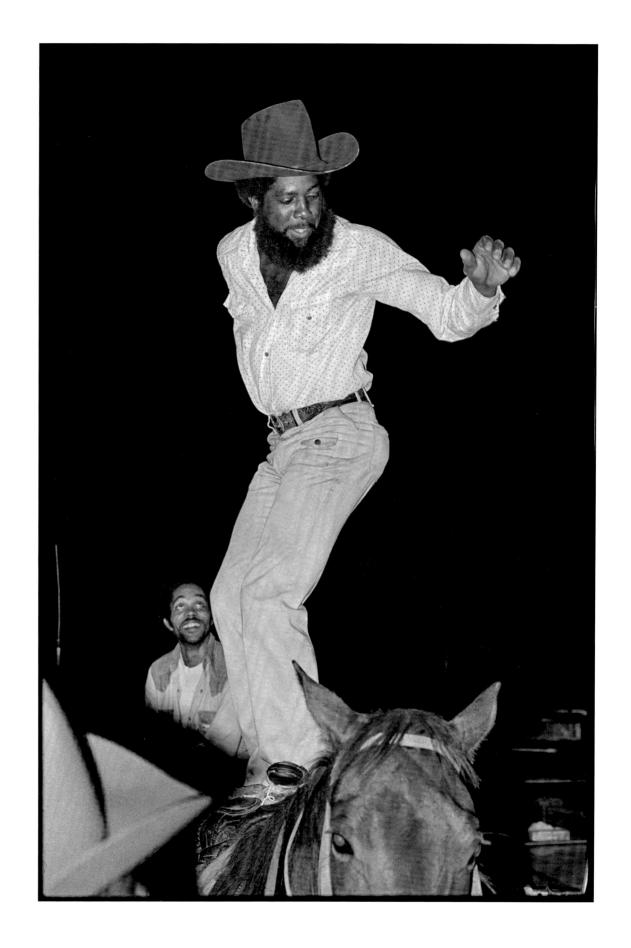

# BLACK RODEO

Afterword by Demetrius W. Pearson

## A BRIEF HISTORY

# In these pages we have been given a nostalgic look at Black rodeo

through the lens of Sarah Bird's camera. Black participants have engaged in rodeo-related activities for more than two hundred years, but it wasn't until the early twentieth century that they began to organize their own competitions. This aspect of Americana has often been ignored or dismissed. Finally, through the many photographs published here, we are given a captivating glimpse into this once-subterranean cultural phenomenon.

Here we have candid photographs of Black rodeo cowboys and cowgirls competing, and of the rustic western environs that afforded them a modicum of peace and solace in the midst of often difficult lives. Together they compose a rich and unique sociocultural time capsule. One of the more fascinating figures photographed throughout the book is the iconic calf-roping legend and teacher Rufus

Green Sr., who was a mentor to many. His expertise in and his influence on the calf-roping event were so pervasive that Professional Rodeo Cowboy Association (PRCA) standouts and mentees were said to be moved to tears at his funeral.

Historically speaking, North American rodeo is arguably the only sport that rivals baseball in its embrace of wholesome American values, morals, and patriotism. Rodeo's proletariat origins and puritanical work ethic have imbued it with a deep-seated sense of Americana, disseminated and perpetuated through myriad media outlets and social institutions. But contemporary rodeo is a sport with its roots in antiquity. Echoes of the aspect of the sport that pits animals against people may be found in early European artifacts and artistic renderings. Bull vaulting, bull fight-

ing, and the running of bulls are all forerunners of rodeo activities. In the Western Hemisphere, the roots of rodeo can be traced to Mexican livestock management practices and the semiannual roundup of wild horses and nomadic cattle. During the roundups, herds were separated, bulls castrated, calves branded, and wild horses tamed. These ranching tasks became somewhat competitive among the vaqueros, which drew family members and friends to watch. Additionally, these early spectacles incorporated the cultural traditions and mores of the Mexicans' Spanish ancestors. This ultimately led to the celebratory fiestas in Mexican territories giving rise to their most revered and festive athletic pastime: *charrería*, or ro-day-o. It would eventually become the national sport of Mexico.

For more than twenty-five years

rodeo has been one of the fastest growing sports in North America, but it has rarely garnered the attention of scholars like me. This has been due in part to its structural inconsistencies, lack of standardization, rural locale, and marginal mainstream media attention (i.e., both print and broadcast). The mythical lore and legendary exploits of the American cowboy, and the embellishment of western culture through "dime store" novels and western music, have also raised suspicions regarding the authenticity of what has been documented over the years. However, with increased marketing in major metropolitan areas, network coverage, and high-profile underwritten competitions (e.g., the Wrangler National Finals Rodeo, the Houston Livestock Show and Rodeo, the San Antonio Stock Show & Rodeo, and so forth), the sport has found a niche audience.

Unfortunately, throughout rodeo's development, certain marginalized groups in the American population were not privy to this burgeoning sport, including African Americans. Partly as a result, the late Dr. C. Allen Haney of the University of Houston and I became fascinated with contemporary mainstream rodeo and its nuanced cultural trappings. From a sociocultural and historical perspective, we believe rodeo is a uniquely proletariat (i.e., working class) sport. This belief became the impetus that led us to conduct numerous research studies on various aspects of rodeo. During our many hours of onsite observation, we paid particular attention to what we didn't see as well as what we saw. At many mainstream rodeos we noticed that there were very few Black cowboys competing. However, as researchers, it was incumbent upon us to investigate other factors besides the obvious ones (racism and discrimination) before passing judgment.

Ironically and quite surprisingly, we serendipitously uncovered a Black rodeo circuit that had been in existence since the 1930s. I later referred to it as a "subterranean" circuit because it had been operating in sundry small rural environs and in designated major agrarian/livestock-friendly Texas cities, like Houston and Beaumont, with little to no media coverage. I also dubbed the Black rodeo cowboys and cowgirls who rode the circuit "shadow riders," because they figuratively rode in the shadows of their white counterparts, thus making them virtually invisible. An often painstaking and exhausting investigation over the past twenty-plus years enabled us to identify other factors contributing to the paucity of African Americans competing in mainstream rodeos, including work obligations, inadequate finances, a lack of training opportunities and basic resources (e.g., quality horses), and a dearth of transportation and accommodations for both rider and animal.

The legacy of Black cowboys, and their rodeo descendants, is an enigma. For more than 150 years they were trivialized, marginalized, and blatantly omitted from the annals of the American West. Yet Black cowboys were major contributors and stakeholders in the development of the western frontier and the all-important Texas cattle industry. Black cowboys in "Mexican Texas" or "Spanish Texas" were intimately involved in the livestock management business, and an indispensable source of labor, before Anglos immigrated to the region and established the Republic of Texas. Unbeknownst to many, the enslaved Africans unceremoniously

transported to the Western Hemisphere by mainly Spanish and Portuguese conquistadors were well acquainted with herding livestock on foot for thousands of years. However, in the "New World" they learned the art of herding on horseback from Mexican vaqueros and charros. Their use of herding equipment, including lariats, spurs, chaps, branding irons, "slick fork" saddles, and "open-tree" saddles, was invaluable in the herding of livestock. Regarding saddles, the Mexican-constructed ones were found to be much more comfortable, work-suitable, and better fitting for both rider and animal. As a result, the Anglos who herded in the Mexican provinces bought, traded, and eventually learned to make similar saddles.

The heroic image and bravado of the Anglo cowboy was engraved in the minds of individuals in the nineteenth, twentieth, and twenty-first centuries through various media outlets, as well as museum artifacts and artistic renderings. However, the original cowboy was an amalgam of Native American and Spanish ancestry (mestizos), Indigenous peoples, African Americans, and Spaniards (a.k.a. criollos) born in Spanish America. The

Black cowboy and his rodeo descendants were Spanish Texas residents but were also brought to the territory as slaves by landowners recruited by Stephen F. Austin. His father, Moses Austin, purchased the first parcel of land from the Mexican government in what is currently the city of Richmond in Fort Bend County. However, young Austin was the one who consummated the deal, shortly after his father's death, and called the settlement Austin's Colony. Over the years it would be known as the Jones-Ryon Plantation (and later George Ranch). Because Austin's agreement with the Mexican government permitted him to farm and raise livestock, he was afforded an expansive amount of land. Black slaves labored in many different roles on this early plantation/ranch. Several were tasked with tending livestock, breaking horses, and eventually herding on the celebrated post–Civil War cattle drives of the nineteenth century.

Once the Emancipation Proclamation became the law of the land and formerly enslaved Black Texans were manumitted at the behest of Union Major General Gordon Granger, on June 19, 1865, the celebration of

their freedom took the name "Juneteenth." It has since been recognized as a national holiday throughout the United States. Currently, more Black rodeos are held on this day than on any other day of the year. Many Black rodeo cowboys and their devotees refer to Juneteenth as "Cowboy Christmas," contrary to their white counterparts who mostly hold rodeos between the Fourth of July and Labor Day.

As noted, Juneteenth rodeos are somewhat sacred within the African American rodeo community; however, Black rodeos in general have been an integral part of the cultural fabric in many small rural environs ever since Floyd Frank's first Black rodeo in the 1930s. There are many parallels between Negro League baseball and Black rodeo prior to integration. Initially, both sports were forced to establish their own separate organizations due to federally sanctioned segregation and discriminatory practices throughout the United States. Therefore, it was incumbent upon both organizations to establish their own standard operating procedures and to coordinate the requisite logistics necessary to stage events.

For Black rodeos the latter included identifying venues, stock contractors with quality roughstock and cattle, sponsors to underwrite events, cowboys and cowgirls to compete, and the requisite rodeo staffers—announcers, judges, and pick-up men—in addition to offering promotional advertising. Unfortunately, there were limited outlets for advertising Black rodeos, as white businesses were reluctant to promote them. Therefore, rodeo promoters had to rely primarily on their respective communities to support their competitions. As a result, special events like mutton busting for children, steer undecorating for women, and bull riding and breakaway roping for "old-timers" were scheduled. The customary rodeo dances, along with all-night camping opportunities, were also designed to increase attendance. Other promotional ploys included providing novelty vendors, concession stand food items, and rodeo apparel for sale, and extending invitations to local dignitaries (e.g., politicians, entertainers, and radio personalities) to make appearances. In many small rural towns, rodeos were far more than mere sport competitions. At times they served not just as social gathering sites but also as the epicenter for civic and community affairs.

As noted, the most salient Black rodeos of the calendar year occur on Juneteenth. Long before it was declared a national holiday, this long-standing celebratory day in Texas has been commemorated with parades and parties, soul food feasts (including fried catfish, barbecue, boudin, red beans and rice, cornbread, collard greens, etc.), traditional beverages (including hibiscus tea, cola, and strawberry soda), and red velvet cake. The red foods, beverages, and desserts served at Juneteenth celebrations symbolize the bloodshed of enslaved ancestors throughout their years of captivity. Juneteenth rodeos were special events, particularly in small rural hamlets in east Texas like Cheek, Raywood, and Anahuac near Beaumont; Dickinson, Texas City, and Hitchcock near Galveston; Madisonville and Crockett near Huntsville; Fresno, McBeth, Kendleton, Richmond, Egypt, West Columbia, and Hempstead near Houston; and in the surrounding counties of Fort Bend, Wharton, Brazoria, and Waller. Several major rodeo venues in Texas stand out among the others: they include the legendary Diamond L (Houston), Floyd Frank Rodeo Arena (Cheek), Circle 6 Ranch (Raywood), R.V. Ranch (McBeth), Menotti Arena (Dickinson), SP Picnic Grounds (Kendleton), Porth Ag Indoor Arena (Crockett), and State Fair Coliseum (Fair Park).

These rodeo arenas enabled some of the most talented Black rodeo cowboys to compete both before and after integration became the law of the land. Although Bill Pickett and Jesse Stahl paved the way for Black rodeo cowboys during the early years of the twentieth century, mid-century icons like Willie Thomas, Myrtis Dightman, Freddie "Skeet" Gordon, Taylor Hall Jr. (a.k.a. Bailey's Prairie Kid), Marvel Rogers, Calvin Greely Jr., Sherman Richardson, Willie Boone, Clarence Gonzales, and the aforementioned Rufus Green Sr. competed in many rodeos where they were not readily welcomed. At many mainstream contests they were forced to compete in an empty arena before the rodeo and fans arrived, in what has been called "slack," or at the end of the rodeo, when spectators had departed. These indignities were even experienced, to some extent, by notable Black cow-

boys competing in the 1970s. These "flag bearers" included Cleo Hearn—fondly referred to as "Mr. Black Rodeo" because of his active involvement in the sport as a rodeo entrepreneur, promoter, and retired calf-roper—Paul Cleveland, Harold Cash, Clinton Wyche, Tex Williams, James Boone, and Cleveland Walters. All have been inducted into a Texas rodeo cowboy hall of fame, as were their predecessors. It is worth noting that Willie Thomas was the premier Black bull rider through much of his career in the late 1940s and 1950s. Many contend he was one of the best bull riders of all time. Unfortunately, like many exceptionally talented Negro League baseball players during the Jim Crow era, he was born too soon. To date, the most celebrated living Black rodeo cowboy is Myrtis Dightman. He was the first Black rodeo cowboy to qualify for the National Finals Rodeo (1966) and was the top-ranked bull rider in the world (1967).

Black rodeo cowboys of the late 1970s through the 1990s benefited immeasurably from the path cleared by their flag-bearing predecessors and were rarely exposed to the overt racism of the past. This afforded Gary Richard, Sylvester Mayfield, Bud Ford, Sedgwick Haynes, Tyrone Francis, and world champions Charlie Sampson and Fred Whitfield unparalleled opportunities in mainstream rodeo, and they "cut their teeth" at many of the arenas previously listed. Their success is due in part to a considerably different social climate, training opportunities with bona fide mentors, quality animals, financial assistance, and unrestricted transportation and accommodation options. These resources enabled an even later generation of contemporary Black rodeo cowboys like Shad Mayfield, Cory Solomon, Ezekiel Mitchell, and John Douch to excel at the highest levels of professional rodeo competition.

Black rodeos have changed over time, much like the Negro League when Major League Baseball desegregated and the most talented players were wooed from their respective teams. Although it is safe to say that Black rodeo competition is not what it used to be prior to integration, it continues to offer a fascinating look at a unique, long-standing sociocultural environment unfortunately forged by segregation. The wholesome communal milieu that provided a "safe space" is still apparent in the delectable cultural cuisine prepared in the spartan arena kitchens and in the toe-tapping music offered (live entertainment at the customary rodeo dance often features zydeco music, a combination of Cajun, rhythm and blues, and country and western), both of which have been captured at the Diamond L Arena through the words and photos of Sarah Bird. The grand entry, in which contestants and dignitaries circle the arena on horseback and in vintage covered or prairie wagons behind the American and Texas flags, is still customary. Another tradition is the riderless horse with one boot turned backward in the stirrup and cowboy hat placed high on the saddle horn to memorialize and salute a deceased cowboy. No longer are Black cowboys and cowgirls compelled to compete solely in Black rodeos within a 250-mile radius of their respective homes. However, many of the customs, rituals, and mores have been handed down to them, and so they carry on.

# PHOTO CAPTIONS

**Pages xvi–xvii**   On this night in 1978, I photographed a legend: Taylor Hall, known professionally as Bailey's Prairie Kid, was on a horse before he was weaned off the bottle, has competed in over four hundred rodeos, and has been inducted into numerous rodeo halls of fame.

**5**   Dubbed the Godfather of Black Rodeo for mentoring several generations of cowboys, Rufus Green Sr. (*left*) helps a friend with a hoof check.

**6**   "Drive-up window" takes on a whole new meaning at a Juneteenth rodeo.

**7**   You won't see a chute man wearing a shirt emblazoned with the Jackson Five anywhere except on the Soul Circuit, circa late seventies.

**9**   While branding cattle at the Clovis Livestock Auction in 1976, the cowboy at the center of the frame does the crucial work of administering oral medication.

**10**   Contestants pin on numbers at one of the few desegregated sporting events in the South at that time, a prison rodeo held in Huntsville in 1976.

**11**   At the Stamford Cowboy Reunion, 1977, a lot of once-traditional Western iconography is on display: hats, spurs, a big chaw of tobacco, man's dominion over nature, and complete segregation.

**12**   A dreamy young buckaroo learns stoicism—the cowboy way—at the 1977 Youth Rodeo Finals in Snyder, Texas.

**12**   A Navajo rider runs the barrels with perfect form at a 1977 Navajo Nation Rodeo Association event held in Gallup, New Mexico.

**13**   This tough cowgirl gets ragdolled around but hangs on until the buzzer sounds.

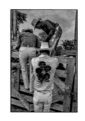
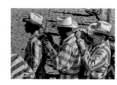
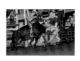
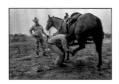
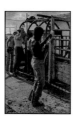
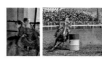
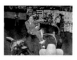

**14**   An impeccably dressed *charro* displays impeccable form at *el coleadero*, bull-tailing.

**15**   Wearing a buckle instead of a badge, this cowboy looks for an opportunity to saddle his mount for the wild mare riding event at a police rodeo.

**15**   This old-timer isn't going to let something like a flesh wound stop him from smoking a cheroot or riding his bronc: anything to hang onto the precious title "cowboy."

**17**   Burnell Jammer, pit master extraordinaire, shows off his wares.

**18**   Here's a cowtot who can't wait to get in on the action. Just don't spur Mama.

**21**   Every cowboy needs a friend to help him pin on his contestant number.

**22**   Russell Mills earned the nickname "Scrap Iron" for his propensity to withstand even a bad buck-off like this one.

**25**   In the summer of 1978, Rufus Green Sr. oversees a jackpot roping at the Pin Oak Community Arena, owned by T. Perkins and sons.

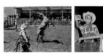
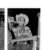
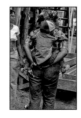
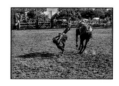

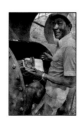
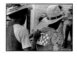
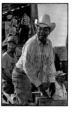

**26** A renowned roper and horse trainer as well as mentor, the Godfather, Rufus Green Sr., displays his peerless equestrian skills.

**29** Sam Calvert and Russell Mills relax after the show is over.

**30** The iconic Taylor Hall, Bailey's Prairie Kid, tugs on his bronc-riding glove at the Diamond L Arena, 1978.

**31** Myrtis Dightman, a seven time finalist at the National Rodeo Finals, examines a trophy while awed cowboys, among them Herman Brown and Randy McCullough, look on.

**33** With Mary Carr (*left*) and Jim Richards (*right*) looking on, it seems as if Dightman, dubbed the Jackie Robinson of rodeo for breaking the sport's color barrier, is reaching into the future to anoint a successor.

**34** Nicknames are essential in rodeo: Dynamite peers over the fence while Bo Pink, a roper and steer wrestler, adds some swagger to the rodeo flyers posted behind him, August 1978.

**35** Burnell Jammer perfumes the air with the intoxicating scent of smoking meat, Juneteenth 1978.

**36** The realest of the real cowboys don't need a big hat to prove their bona fides. A gimme cap from the feed store will do for these ranchers, conferring before the rodeo starts.

**37** A Juneteenth event is about reunion as much as it's about rodeo.

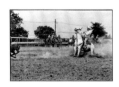
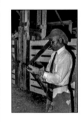
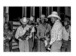
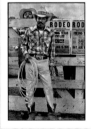

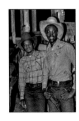
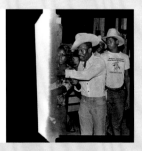
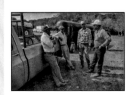
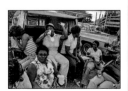

**38** A champion-roper-in-the-making limbers up his lasso.

**39** It's an Oops Moment when this baby buckaroo hears his mother calling out his name.

**40** A Juneteenth rodeo highlight: sharing a pickle with baby sister.

**41** What cowgirl could resist the devilish twinkle in this junior buckaroo's eye?

**42** Malloy Scott (*center*) grins as a pal reveals the name of the fearsome bull that he drew.

**43** Rodeo secretary Gladys Carr, affectionately known as the Queen Bee of the Diamond L, registers Jimmy Powell and collects his entry fee.

**44** Lois and Leon McCullough wait out the heat with their two children and many others; everyone is anxious for the rodeo to get underway.

**45** The charismatic Louis Brown and his wife Dorothy are in high spirits as they wait for the show to start.

**46** A lucky bull rider (*left*) has the great good fortune of having bull-riding legend Myrtis Dightman help him rosin up his rigging.

**47** A roper limbers up his lasso and himself for the breakaway calf roping event.

**48** There's always something to grin about at a Juneteenth rodeo at the Diamond L Arena.

**49** Ernestine Rogers rounds the third barrel and prepares to take it home.

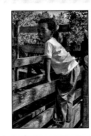
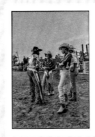
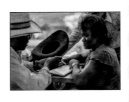
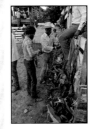
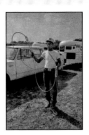
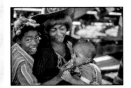
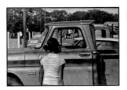
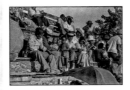
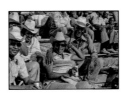
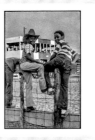
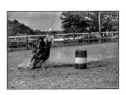

50 At a jackpot roping outside of El Campo a dragonfly hovers above this contestant like an unmanned drone.

51 Only a Black cowboy could make a floral yoke, silk kerchief, and gold necklace look both suave and intimidatingly badass.

52 A lull in the action has these two cowboys staring off into space.

53 A young rider breaks the rope barrier to start the timer on his run in a jackpot roping at the Pin Oak Community Arena.

54 Archie Wycoff gingerly settles onto a skittish bronc. Cowboys fear a chute-fighter, which can weigh upwards of 1,200 pounds and can crush a man's leg just by leaning the wrong way.

55 This barrel racer shaves seconds off her time by running the cloverleaf pattern tight and at a furious gallop.

56 A hapless, and now hatless, contestant takes a low-scoring, uninspiring ride aboard an uninspired bull.

57 With his hazer, J. B. Collins, herding the steer into perfect position, Bo Pink drops down on the thundering animal's head.

58 The judge in the striped vest and the pick-up man on horseback make sure that the rider has "marked out" his mount. The "mark out" rule requires bronc riders to have the rowels of both spurs in front of, and touching, the break of the bronc's shoulders on the animal's first move out of the chute.

59 Scrap Iron, ready to move on to the next event after being bucked off hard, shows how he earned his reputation for indestructibility.

60 Rufus Green displays the patient tutelage that earned him his Godfather title. At his small ranch outside of Hempstead, Texas, he shares some tips with his grandson.

61 Grandpa smiles with pride as the newest Green-trained roper gets it done in championship style.

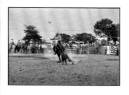
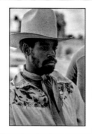
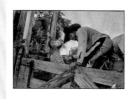
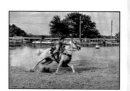
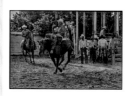
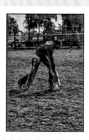
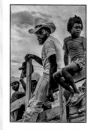
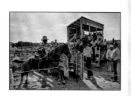
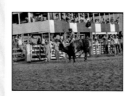
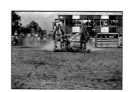
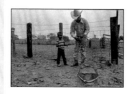
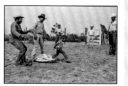

62 A calf roper thunders after his target at a competition held outside of El Campo, Texas.

63 A spectator sprints into the arena to help with the tie-down.

64 Renowned rough stock rider Archie Wycoff has the crowd on its feet as he starts his eight-second run.

65 Wycoff hangs on until the eight-second buzzer for another winning ride.

66 Chester Green brings a bit of Bourbon Street to the Diamond L in the summer of 1978.

67 Pitmaster Burnell Jammer prepares to serve up some of his creation. Popular drink choices are Big Red and Golden Age orange soda.

68 A beautiful and beautifully trained roping horse is the true star at the Circle T Arena.

69 A chute man, trusty chute hook by his side, takes a break to watch the action with none other than Myrtis Dightman by his side.

70 Johnny Gold, tie-down calf roper, gets the job done in winning time.

71 A steer wrestler's horse gallops free, leaving his rider in the dust (on the ground between and behind the two horses) to try to wrangle the steer into submission.

72 Seen here at the Circle T Arena, team roping is a delicate collaboration between header, who ropes the steer's head; heeler, who lassoes its feet; and two impeccably trained horses.

73 The flag man at the Circle T Arena has dropped his flag, signaling to the timer to stop the clock.

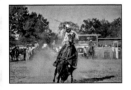
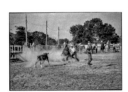
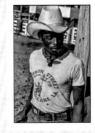
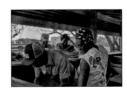
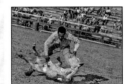
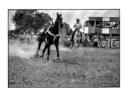

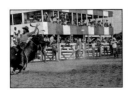
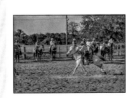
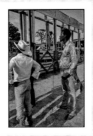
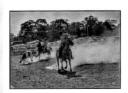
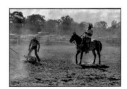

74 What's hotter at a Juneteenth rodeo? The temperature or the gossip?

75 Robert Doogie, his wife by his side, pays tribute to the T-shirt-worthy Myrtis Dightman.

76 Buster and Ed Thorn were deeply authentic working cowboys. Veterans of fabled ranches, the 6666 and the Shanghai Pierce, these master equestrians didn't need reins to keep their horses under perfect control.

77 The magic moment when a roper drops his lasso onto a scampering calf is captured.

78 Business slacks off in the late afternoon when all the brisket is gone and it's just about time to head to the bar.

79 Silhouetted in the light of a setting sun, these old-timers discuss the days when being a cowboy meant long days—years!—on the back of a horse, not just hanging on for eight seconds.

80 A couple of thirsty fans welcome all comers to the Blue Lagoon Saloon, where many a victory in the Diamond L Arena was celebrated and many a loss forgotten.

81 Business is always brisk at the Blue Lagoon after a Juneteenth rodeo at the nearby Diamond L.

82–83 It's 4:35 at the Blue Lagoon, time to soak in some of the AC that's ruffling the Christmas streamers overhead and throw back a few cold ones.

84 Louis Brown offers a word of caution to a city girl photographer foolish enough to stay in the arena during the bull riding.

85 Archie Wycoff reaches up for a handful of sky as he marks out his bronc. The judge noting his performance is Lloyd Randall, more famous for having played baseball in the Negro League.

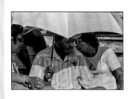
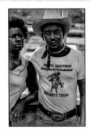

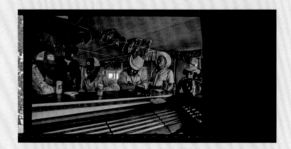
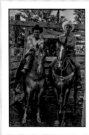
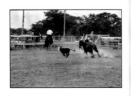
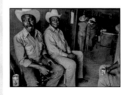
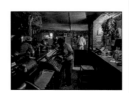
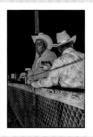
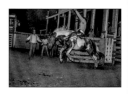

**86** Jackie Smith (*center*) and Willie Boone shake on a bet about whether or not the next rider will hang on for eight seconds.

**87** A trio of Diamond L staffers strategizes.

**88** A veteran settles onto his bronc.

**89** Rodeo judge Lloyd Randall (*far left*) notes on his clipboard that the rider has "marked out" his bronc, while Russell Mills, next to Randall, and Archie Wycoff, in chaps, look on.

**90** No product placement for this fan enjoying an anonymous beer.

**91** A roper is frozen at the moment when horse and calf have six hooves in the air, two on the ground, and the lasso is about to drop onto its destination.

**92** Gladys Carr discusses the scoring with several men while Myrtis Dightman, behind her, listens in. Next to her in the straw hat is the stock contractor Johnny Ackels. On the far right, Herman Brown admires a friend's trophy.

**93** A post-ride analysis gets a big laugh.

**94** Tie tucked into his waistband, stogie firmly in place, the master known as Bailey's Prairie Kid prepares for one more ride.

**95** It was an honor to capture the fabled Bailey's Prairie Kid on one of his final prize-winning rides before he retired from rough stock riding.

**96** The moment of truth arrives. Gladys Carr is about to deliver the final results to the announcer.

**97** Backing up the jubilant woman celebrating the winners are (*left to right*) James "Jack" McCullough; Mary Carr, daughter of rodeo secretary Gladys Carr; the great Myrtis Dightman; Jim "Baby Jim" Richards, son of the renowned announcer Jim Richards; and Russell Mills.

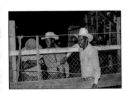
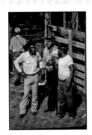

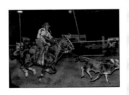
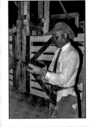
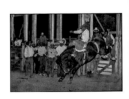

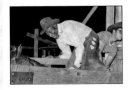
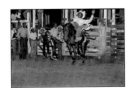
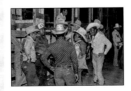
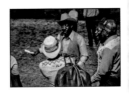
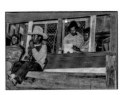
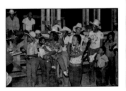

**98**  More at home in the announcer's booth than in the arena, Jim Richards has his pain eased by a trophy.

**99**  Whoever won the grand prize of a saddle gets a big laugh from his fellow competitors, showing that the true grand prize at an old-school Juneteenth rodeo was always friendship. And the big laugh.

**100**  Known as "Half Pint" to his friends, this enthusiastic fan invites the rest of the crowd to join him as he heads out to the nearby Blue Lagoon Saloon.

**101**  Friends Sam Calvert (*left*), Ray Brown, (*center*), and Russell Mills (*right*) celebrate at the Blue Lagoon Saloon.

**102**  This stylish cowboy wears the hell out of that hat and those boots.

**103**  Bailey's Prairie Kid's moves are just as smooth on the dance floor as they are in the arena.

**104**  The classic cowboy brothers Ed Thorne (*fifth from right*) and Buster Thorne (*in black hat, crouching*) rejoice in being together with old friends for one more Juneteenth rodeo.

**105**  An impossibly cool Black cowboy dances a farewell at the end of a night rodeo in Bastrop, Texas.

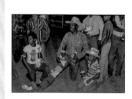
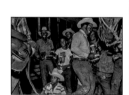
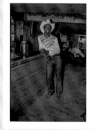
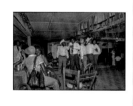
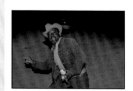
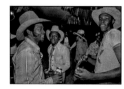
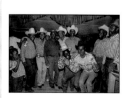
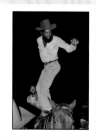

# ACKNOWLEDGMENTS

I am indebted to the incomparable Rufus Green Sr., the Godfather of Black Rodeo, for welcoming me into and guiding me through his world.

Starting with Larry Callies (founder of the Black Cowboy Museum), Randy McCullough, Pastor Chris Carter, and Too Pretty Nadine, I thank all those who contacted me with information about the identities of my subjects. Demetrius Pearson was a generous and invaluable source who shared my photos with many of his rodeo contacts, including Hall of Famer Harold Cash, who verified names and provided many more.

I am forever grateful that my long-time UT friend, the iconic Texas photographer Will van Overbeek, generously stepped forward to lend his expertise in digital editing. More than that, he lent his impeccable eye, flawless aesthetic, and documentary judgment to making my ancient analog images shine in their fullest glory and tell the story they were meant to tell. Will made this book possible.

David Coleman, Steve L. Davis, and Carla Ellard of the Wittliff Collections were the handsome princes and princess who kissed my sleeping photos back to life by accepting them into their archives and digitizing them into the twenty-first century.

I cannot thank Casey Kittrell enough for having the vision from the start to appreciate and champion the importance of this photo archive and its place in the newly reclaimed history of Black people in the West. Each project I am fortunate enough to work on with Casey makes me appreciate even more the subtle grace and intelligence of his editorial guidance. A book as complicated as this one also allowed me to appreciate his skill at shepherding even the most intricate project with patience and diplomacy.

And hallelujahs to Lynne Ferguson. Copyeditor does not begin to describe this kind, collegial, clarifying force who straightens out all the misaligned trees so that we can see the forest as it was truly intended to be seen. Thank you, Lynne.

The indispensable comrade on this journey has been the remarkable Derek George. Derek created an exquisite design that harmonizes the written and visual in a way that enhanced both photos and text and elevated the book far beyond anything I could have imagined.

It was my tremendous good fortune to have been introduced to UT Press by Gianna LaMorte. She is my friend and my source of infallible advice on all things publishing, as well as being an innovator, champion of women, and one of the three funniest humans I know.

Cameron Ludwick, Bailey Morrison, and Joel C. Pinckney are vital parts of why publishing with UT Press is such a joy. I thank them for

their publishing expertise, promotional acumen, unfailing good humor, and ingenuity in helping me track down the identities of my subjects and making this project come alive on the internet.

Essential to UT Press's ever-growing success and national stature is its farsighted Advisory Board. I thank them for recognizing the significance of this project and for their crucial support through its development.

I would be remiss if I didn't thank the University of Texas Photojournalism Department, including professors J. B. Colson and Larry Schaaf, as well as my great buddy and technical wizard, the ultimate Austin chronicler, Robert Godwin, for giving me just enough training, encouragement, and darkroom time to get into some "good trouble."

And finally, George Jones.

He comforted me in the early 1980s when my proposed book of Black rodeo photos was rejected, and he celebrated with me almost half a century later when it was accepted.

George Jones, you are the second greatest gift of my life.